Northampton Memories

CHRISTINE JONES

AMBERLEY

First published 2016

Amberley Publishing
The Hill, Stroud
Gloucestershire, GL5 4EP

www.amberley-books.com

British Library Cataloguing in Publication Data.
A catalogue record for this book is available from the British Library.

ISBN 978 1 4456 5745 5 (print)
ISBN 978 1 4456 5746 2 (ebook)

Origination by Amberley Publishing.
Printed in the UK.

Contents

Introduction

Northampton has changed dramatically over my lifetime and this book is a collection of memories of life in Northampton through the years. My involvement with the Northampton Past Facebook group and other local history groups has made me realise that we have a wealth of memories that are too precious to lose.

One lady in particular made a big impact on me when she shared her memories of growing up in Northampton. Sue Hardwick wrote with such honesty that I read her memories with tears running down my face. She made me realise that people don't want a sanitised version of the past – they need to know what it was really like. It wasn't always perfect and some things have improved greatly over the years, but we loved our town because it was ours, it was where we belonged and we valued what we had. If we want people to value the buildings and places that matter to us they need to understand something of their history and importance to the town. That is why it's so important to preserve memories of our past.

I feel very fortunate that so many people have contributed to this book and between them they cover every decade from 1910s to 1990s, sharing memories of many different parts of the town. Sadly, Sue Hardwick died recently but I'm very grateful to her husband for allowing me to include some of her memories in this book.

Home and Family

I was born in 1918 in Leslie Road, Semilong, and I have lived there all my life. There was no hot water in the house. We had to boil a kettle and have a strip wash but every month we had a hot bath at the slipper baths in Saint Andrews Road. Clothes were washed in a copper with a fire underneath it to heat the water. The only heat was a coal fire in the living room, lit only when it was very cold.

We kept chickens in the garden so we always had fresh eggs. There were lots of little shops around us. My mother bought a penny worth of sugar and a penny worth of jam. For dinner we always had stew and potatoes, rabbit was a treat, usually it was bones and vegetables. At Christmas we had one of the chickens for dinner.

We played football and marbles in the street and we swam in the river at Millers Meadow. Everyone smoked, so the kids collected cigarette cards, we used to skim them. We didn't have a radio at home.

I went to Spring Lane School, then to Saint George's and finally Campbell Square School. I left at fourteen and was employed by Churches shoe company all my working life, except during six years' service in the Northamptonshire Regiment. I travelled all over the world.

My father was often on short time or laid off, so life was very hard. He worked in the shoe trade for a company in Ardington Road. He died when I was twelve, so, to make ends meet, my mother finished handbags in one of the bedrooms. I had a paper round and I was paid half a crown, two bob for my mother and a tanner for me.

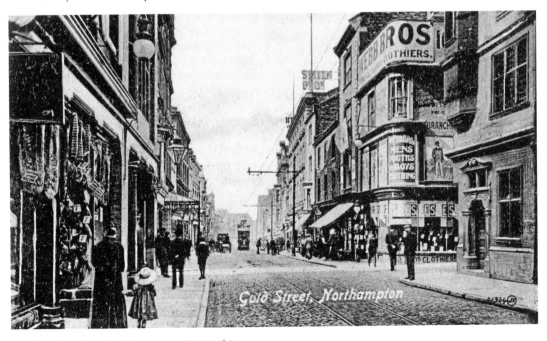

Looking down Gold Street towards Marefair

We paid a penny a week to the doctor so that he would look after us if we were ill. There was an epidemic of scarlet fever and I was very poorly but the doctor took care of me.

The community in Leslie Street was brilliant. I have visited every house in the road at some time or another. We all knew each other and we would help each other when needed. We got excited when the first car arrived on the street, it came to number nine. Today I only know a few people, which is sad.

George Smith

My grandfather was a very caring man, but he used to swear like the devil. He used to get drunk too. They lived off Wellingborough Road and when Mum was a girl, Grandma would send Mum and her sister to look for him. He would be singing to the Bradlaugh statue on Abington Square, he sang 'three cheers, three cheers for Bradlaugh' but he would go home with them ever so peacefully – he was an amicable drunk.

Joan Clarke

1920S–1930S

My first home was two rooms over a shop in Kerr Street, two rooms above the shop. We moved to Norman Road and then, when I was three, we moved to nicer rooms in Victoria Road near the church. I was five when my grandfather died and we moved to Kerr Street to be with my grandmother.

People Mum knew were given a brand new council house in Abington. They had never had a bathroom, so they kept the coal in the bath. People weren't dirty, we were used to having a strip wash, people managed with what they had and sometimes it's hard to break old habits. I didn't have a bathroom or an indoor toilet until I moved into a council house in Kings Heath in 1951. I thought I had moved into a palace!

Joan Clarke

1930S–1940S

I couldn't go to dances because of the war, but afterwards my younger sisters went to the Salon when they were old enough. My youngest sister never came home on time, she pushed it to the limit. Dad was a tender-hearted man and he would have worried terribly if he'd known she wasn't home so Mum took me to Campbell Square to look for her. The Salon was in Weedon Road so it was all uphill coming back. Mum would see her coming and all of a sudden she would shout 'Margaret!' and start telling her off before she even got there.

We lived with Mum and Dad after we got married, we had the front room. We couldn't get a council house until I was expecting my second child. My daughter was five when we moved to Kings Heath in 1951.

Joan Clarke

1940S–1950S

I saw a lot of the town when I was growing up. I was born in St Edmunds hospital in 1942 and I lived in Victoria Gardens in a three bedroom house with my grandmother and my parents,

next door to my aunt and uncle. We had gas light but there was no light on the stairs so we used candles. There was just an outside toilet and a tin bath, which hung on the wall outside. I went to the 'new baths' on the Mounts sometimes when I was older, it was lovely, the water was very hot.

When I was four, my parents moved to a two-up two-down house in Oxford Street, Far Cotton. Our next move took us to Ruskin Road, Kingsthorpe and unlike some of our neighbours we had a bathroom with a toilet. I liked living there, we had a big apple tree in the backyard and a sweet shop on the opposite side of the road. After three years, we moved back to Victoria Gardens because Gran was ill and Mum had to look after her.

Gran died and we had to move because it was a rented house; we were given a new council house in Medway Drive, Kings Heath. We were pleased to get the house; Kings Heath was a sought-after place to live in those days. It was a lovely house, there were Marley tiles on the floor, so we didn't need carpet and it was a luxury to have a proper bathroom. We had good neighbours and there were lots of children to play with. The estate was still being built so our nearest shops were at Glebeland Road. I remained at St Mary's but I think Spencer was the nearest school. Milk was delivered by horse and cart and one day there was a horrible accident when the horse was badly frightened and bolted.

Later on, circumstances made it necessary to move nearer the town so we did an exchange and moved to Brockhall Close on the St Davids Estate. When we lived there the Co-op bread van delivered to us and we had to pay with tokens.

Yvonne Bodily

I lived in Delapre Crescent Road, Far Cotton. My father was a keen gardener and he produced some magnificent incurved chrysanthemums and giant Pompom and Cactus dahlias, which he sold locally. His skills were greatly assisted by the horse-drawn carts that passed by, owned by the Co-op milk service and the coal merchant. I can picture him chasing down the road with a shovel and pan! Our neighbour grew tomatoes and he gave me one or two small ones when I went to buy some for Mum. The distinctive smell of home-grown tomatoes lingers long in the brain, as does the song of the blackbird that serenaded us most evenings.

Colin Skears

1950s

On Saturday night when he finished work, Dad went out for a drink to the pub next door. We didn't have a bathroom so we washed in the kitchen or used the tin bath in the kitchen. Dad sat at the table with a bowl of hot water to have a shave. The kitchen was just a lean-to, with a corrugated iron roof. There was a copper in the kitchen to heat water for the bath and we had a little Sadia water heater for hot water.

Brenda Broome

My first home was an old three-storey town house next door to the Roebuck Inn in Grafton Street. We moved there 1953, when I was a baby. My parents rented it from the owners of a shop on the corner of Grafton Street and Fitzroy Terrace called J. A. House. It was very cold in the winter. We washed in the kitchen sink and had a tin bath by the fire, the toilet was outside.

In 1960, we moved to a new council house in Kings Heath, which became our family home for the next fifty-three years. It was perfect, our garden backed onto fields overlooking Wilson's farm and the Firs. The house had a coal fire with a back boiler so we had hot water from the tap, three

St James Square, 1956. (© Sue Hoggarth)

radiators and a bathroom. The country air did wonders for our health and my sister's asthma disappeared! We transported the goldfish 'Topsy' to our new home on the number 10 bus.

My grandmother, aunts, uncles and cousins lived in Campbell Street. Grandma's shop was called The Stores. It sold Corgi and Matchbox toys, hardware, crockery and the most beautiful ornaments; it was like Aladdin's Cave. My aunt and uncle owned Buswell's shop in Campbell Street, they sold British wines, sweets, cigarettes and groceries. They had an on-licence so folk would call in for a glass of wine before going to the Cinema de Luxe a few doors away.

We loved helping Mum with baking in the mornings. The washing was boiled up in the copper on Mondays; I still remember the smell of hot soapy water. Afternoons were spent in Paddy's Meadow (Millers Meadow) or Victoria Park. We visited our grandparents in Kingsthorpe for tea on Saturdays and watched *Six-Five Special* on their television. My grandfather showed us the coloured maggots he had ready for his Sunday fishing trip and I loved learning about the vegetables and flowers in their garden.

Gill Felton

My parents had been in the war and when they married in 1944 they struggled to find anywhere to live. After a couple of years with relatives they managed to rent a dilapidated house; it wasn't ideal but they needed a home. St James Square was up steep steps off St James Street. The tiny house had a musty smell due to damp and it was very dark despite my parents' efforts to brighten it up. The sparsely furnished front room was rarely used, except on Sundays or for visitors. Coal fires were hard work and expensive so we used the cramped living room for everything. When the chimney sweep came, all the furniture was covered with old sheets and I stood outside waiting to see his brush pop out of the chimney. We didn't have a cellar so the coal was kept in the backyard; the coal men carried big bags of coal on their backs right through the house. Steep stairs lead to the two unheated bedrooms. The odour of mothballs dominated my parents' room but thankfully there wasn't space for clothes in my room.

The big brown push-button wireless was my entertainment. Even as a toddler I loved music and I waited eagerly for *Listen with Mother*. Our elderly neighbours had an ancient radio with

an accumulator, which occasionally had to be taken to a company called Wireless Relay to be charged. Sometimes, men from the same company came round to test the wires by putting a pole up to each wire and we heard a burst of music each time a wire was touched. I think it was to check the service for the people who rented their radios.

We got a television in 1955, it was very exciting and I looked forward to *Toytown* with Larry the Lamb. It took a while to warm up when it was switched on and the white dot on the screen took ages to fade when it was switched off. BBC was the only channel and, with the exception of *Watch with Mother*, daytime television was very limited. I became familiar with the short clips of film known as interludes and the daily trade test transmission. I loved the *Woodentops* and *Six-Five Special* was another favourite, it had the latest pop songs singers like Tommy Steele and Lonnie Donegan. We were lucky, some houses didn't even have electricity, they still had gas lights. I didn't have many toys but when I had my toys out there wasn't room to move so I often sat at the table playing or colouring.

Our tiny kitchen had a deep butler sink with a wooden draining board, an old pale green gas stove, a gas copper and a little cupboard with food stored in it. Mum shopped almost daily because there was no fridge and nowhere to store food. A huge mangle stood in the yard ready to be wheeled in on washday and two old tin baths hung on the wall. I bathed in the smaller one, which was probably intended for laundry. My parents filled the bath with kettles, perhaps they heated the water in the copper. The toilet in the yard had an old wooden seat that stretched right across with such a big hole that I was afraid of falling down. Some neighbours still had bucket toilets, ours was connected to the sewer but we had to flush it with a bucket of water. The landlord fitted a flush toilet about 1955, it was still outside but it was lovely to just pull the chain.

We moved to Berrywood Road in 1957 but the properties survived until 1966. I was reluctant to leave my home but the prospect of a council house with a bathroom was enticing. Dad established a garden and grew almost all our vegetables. The rent was higher and there was no money for treats.

Sue Hoggarth

I was two when we moved to Abington Avenue near the County Tavern, where I lived until I married in the 1980s, so I was an Abington Avenue boy.

Clive Hardwick

I was sad to leave St James Square but our new house in Derwent Drive, Kings Heath, had a bathroom with a toilet! Fluff, our cat, went back to the old house but after a fortnight we got him back; even the cat didn't want to leave, he probably missed his friends too! When I went back to see the old houses, I was shocked to see a large amount of rubble. All our beloved houses had gone forever and the first chapter in my life was just a memory.

Michael Cunnew

1950S–1960S

We moved to Herbert Street in the 'The Boroughs' when I was five. I have clear memories of the old tin bath, which I so hated. We had to take it in turns to use the same water because it took too long to fill each time and water had to be carried up and down a flight of stairs, to and from the kitchen.

Our toilet was a small brick-built shed at the top of the garden away from the house. We hated it, it was scary and at night we used pots indoors which were emptied and washed every morning. There was no light and there were rats and mice in the area where houses were being knocked down around us, so it was not safe to go out there at night. Outside the backdoor, Mum kept a tin bucket full of water in case anyone was in a hurry. We had to take it with us and use it to flush the toilet. Then we had to fill it afterwards and put it back ready for the next time.

One day my sister went up the garden in the day time, bucket in hand, nothing to be ashamed of as everyone in our street had to do that. She used the loo and as she stood up and wiped herself she looked behind her and saw, to her horror, she had been right on the head of a rat that was in the loo. She did not stay to flush it. She came hurrying down the path, screaming her head off and trying to run and pull her drawers up at the same time; she was almost falling over with every step she took. She screamed so loud half the street heard her and everyone rushed to their back-room windows. She got teased a lot about that.

Mum told me to see the coal in and reminded me several times before she went out to make sure the door between the cellar and the kitchen was tightly closed. What a mistake failing to close the door was! After three bags of loose coal were dropped from above it resembled smoke clouds trapped inside the walls of the house and settling in thick black dust on everything. All alone, aged about nine, I had to wash the whole kitchen down; dishes, pots, pans, the lot, before Mum got home. I didn't manage it and she was so mad she made me finish it.

When we moved to Abington, I felt we now lived in a posh house. We had a bathroom downstairs with a proper bath and running water and an indoor toilet upstairs.

When my time at the junior school was over, I understood that Mum and Dad could not afford to buy me a new school uniform. I wasn't worried. I was used to making do, but I wanted at least one new blouse and Mum promised me I would have two. I never knew how dire our finances were at that time so I did not understand what Mum did for a long while. One day I came home from junior school to find two pure white crisp new blouses hanging on the wall. I was thrilled. Later when I was in bed, I heard voices in the room below; one was my cousin and I heard her say, 'Well, did she like them Eva?' I heard Mum reply, 'Shhhh! She'll hear you, she doesn't know they were Marie's and I had them from you. She thinks they are new, and I don't want her to know, do you hear me?'

The following day I went to school wearing an old blouse, I had no intention of putting on one of those hanging up. Father made sure I did wear them, of course, and I got over it given time.

Sue Hardwick

1960s

I was two when we moved to Kings Heath, it was a brand new house. Previously my parents had lived in Hanslope, where Mum grew up. Our home on Swale Drive was in a beautiful area with a lot of trees and plenty of space. It was safe for children to play outside because there weren't many cars, there was open space and areas of grass where we could play. We were lucky because our house backed onto the fields and they didn't build behind us during my childhood, so we had a whole field to play games with our friends or watch the trains. When I was about eleven, they created a big playing field nearby too.

Carol Grammer

Adams Avenue, 1972. (© Sue Hoggarth)

I was eighteen when we moved back into town. Mum found Duston too isolated and longed to move, and in 1969 they were finally able to buy a house in Adams Avenue. It was a bigger house and I was so much happier because it was very friendly and everything was close by.

Sue Hoggarth

1970s

I lived in a council house in until the mid-1970s when my parents, by then in their mid-forties, bought their first home. We had a 'coal hole' in the council house, which was a dark cupboard in the kitchen and the coal man came to deliver coal. There was a big old-fashioned water heater on the kitchen wall. Our settee was orange and cream, and we kept all the crockery in a huge sideboard in the lounge. The radiogram was a big piece of furniture, we lifted the lid to play records or listen to the radio.

When I was eight, we moved to a terraced house in Seymour Street, which smelled damp and musty at first. My bedroom was decorated in jazzy colours including pinks and purples. We left a big garden bursting with flowers for a tiny yard with one flower bed. I think that was my Dad's biggest regret.

Gayle Law

Frank White in Adams Avenue, 1970. (© Sue Hoggarth)

1970s–1980s

I lived in a nice three-bedroom council house in Broadmead Avenue throughout my childhood. It was a very busy road, but as children we played in the front garden and in the street with clear boundaries to keep us near the house. Gradually the boundaries were extended until we were allowed to go to Eastfield Park. When we had to go home my Uncle Archie, who lived next door, stood in the back garden and whistled so loud that we would hear him and come home. We felt perfectly safe.

The house always seemed cold when I was little. We had an oil radiator in the dining room, and Mum used convector heaters to take the chill off the bedrooms at bedtime. I will never forget how amazing it was when we turned the central heating on after it was put in. Mum looked after the house and Dad took care of the sheds and the garden; we had a lovely garden.

Tracy Webb

Local Area

Grandma used Wallingtons the butchers on the corner of Wellington Street, and a grocery shop in Wellington Street. Later we used Mr Dick's shop in Lady's Lane, and there was a good fish and chip shop further along. It was tuppence for a piece of fish and a penny for a bag of chips; that was a real meal. Children used to ask for batter bits, you could buy a penny-worth of batter bits.

Joan Clarke

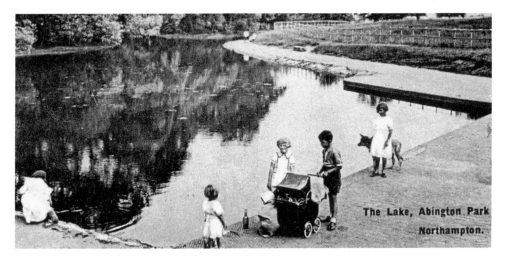

The Lake, Abington Park
Northampton.

Children playing in Abington Park.

1940S

The Plough was the nearest pub to Victoria Gardens and the adults very often went there in the evenings. It was difficult for women because they were often accused of having affairs with American soldiers. Gossip is very damaging, but I think in most cases things were quite innocent.

We were rationed in the war, so we couldn't get many sweets, but I remember a sweet shop in Victoria Gardens. It was an unusual building, we called it the Swiss Cottage.

Yvonne Bodily

1950S

Raphael Tuck's card factory in Bridge Street was close to our home Victoria Gardens. It burnt down in the 1950s after we moved away. It was a very bad fire and people had to be evacuated from their homes.

Yvonne Bodily

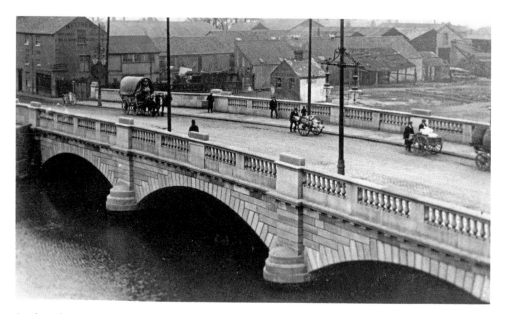

South Bridge.

When I left school in 1954 I worked at Kings Butchers on Kingsthorpe front. I delivered meat and produce around town on an autocycle with a large and frequently overloaded carrier on the front. Two doors down there was another butcher's shop called Blundell's. He had a Lambretta motorcycle in the front of his shop but he never would sell me it, although he never used it. I left in 1956 when I joined the Royal Navy.

Lawrie Harold

Before that side of St James Road was knocked down, there used to be a wool shop next door to the post office. After the redevelopments, both shops moved to the new precinct close to where their shops had previously stood. Many other business were lost, including the West End Tramcar on the corner of that row of shops. Before the redevelopment there was a police box on the other corner towards the Weedon Road and a couple of shops, Gunthorpe's and Mitchell's.

When we were kids there was a very big house on Weedon Road before Franklins Gardens, it was like a mansion with big columns at the front. I think they demolished it in the 1950s and houses were built on the site.

Roger Broome

I had my eyes tested by Mr Green at his chemist shop when I was about thirteen. He had a couple of different premises in St James Road but he ended up in the little shop on the corner of Bowdon Road. It was dark inside with old apothecary bottles and cabinets with each drawer carefully labelled. He made up his own cough mixtures, medicines and liniment in glass bottles with cork stoppers. We bought tincture of myrrh for toothache and Grandma bought camphorated oil (which came in a ridged bottle) to make camphor bags. They smelled awful, we had them pinned to our liberty bodices to protect us from colds. We bought malt toffee in a jar from Mr Green, it was lovely. We had it on a spoon every morning, the only problem was that we had to have a spoonful of cod liver oil first.

Brenda Broome

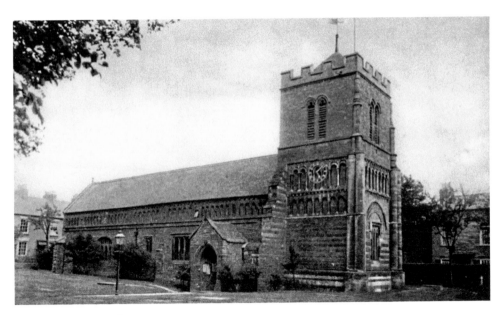

St Peters Church, Marefair.

Memories of sitting on the steps of the Green Dragon in Bearward Street and other pubs on the Mayorhold are quite clear to me. It was great for me as I was always given a penny or two from the men going in and coming out.

Sue Hardwick

One night, when I was about three years old, there was a big fire not far from where we lived. I woke up and Mum took me to watch the flames from the window. My cousin who was five remembers that his parents woke him and took him out to watch the fire. It was a greetings card factory belonging to Raphael Tuck near the bottom of Bridge Street. Mum took me past the gutted building the next day and there was charred black paper everywhere.

The local children all played on St James Square and I had a marvellous time when I was little. Although it was a rundown area I was happy because my cousin lived nearby and there were always children to play with. I was forbidden to go down the steps, I could have easily fallen down them but I never did. My cousin and I both had scooters and we raced each other up and down the square but we always braked and stopped before the steps. When I came in from playing my knees were black with dirt and Mum struggled to get them clean. Sometimes she used a nail brush on them because the dirt was engrained, but afterwards she rubbed cream into them.

As I got older I was allowed to go down the steps to buy sweets from the tiny shop owned by Mrs James. Wearings factory was next to the shop; my neighbour worked there as a machinist, they made raincoats. There was a gas lamp at the bottom of the steps near St James Square. A man in dark uniform came each evening with a long pole to light the lamp, but I don't know how it was turned off in the morning. An electric street lamp was installed several years before the area was demolished in 1966 but the gas lamp remained and it was the last gas lamp in Northampton.

Mum did her daily food shopping in the surrounding streets. There was a dairy called Andertons and a little greengrocers' shop where you stood across the counter from the shopkeeper and you

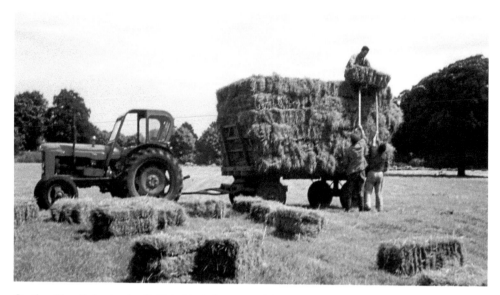

Carting Hay Bales in the field behind the council houses in Berrywood Road, Duston, 1966. (© Sue Hoggarth)

were given the things you asked for. She bought some food from Woolworths in Gold Street, it had counters all the way up and customers asked for the things they wanted. Sugar was still weighed into blue bags and they had big tins with loose biscuits. You could buy half a pound of whatever biscuit type you wanted and they shovelled them into a paper bag. You could also buy broken biscuits, we got them occasionally but a lot of people existed on broken biscuits.

I remember the sweet shop near All Saints' School. The shopkeeper was known to us as Granny Waters. She dressed in long black clothes, a white apron and a little white cap. She seemed ancient and, due to her deafness, communication involved a lot of pointing and gesticulating. It was a tiny little shop with big jars of sweets along the walls and a counter displaying chocolate bars, gobstoppers, flying saucers, liquorice laces and liquorice pipes. Occasionally if she was unsure of a price she consulted her mother – an even older version of Granny Waters dressed in the same way, who sat in the back room in a rocking chair making lace. I couldn't believe that Granny Water could possibly still have a mother!

It was a poor area with some very poor children. I was lucky because I always had nice clean clothes, but some children wore clothes that were almost rags with terrible old shoes and a few were quite dirty. There were some very poor people living there but I didn't realise it then.

When we moved to Berrywood Road we shopped in Duston village. I bought my comics from Law's newsagent and post office. When I was too old for *Playhour*, I read *Dandy* and *Beano* until I discovered *Bunty*. I liked a magazine called *Boyfriend* for the double-page popstar pin ups in the middle. The first star I really liked was Russ Conway, he played the piano but the first real popstar I liked was Adam Faith. In 1963 I discovered the Beatles and that was it for me, I got into music in a big way.

There was a greengrocer, a Co-op, a hardware shop, Taylor's grocery shop and Adam's general stores. On the other side of Main Road there was a shop called Mary Finch which initially sold wool but later it became a hairdressers. Faulkner's bakery also sold cheese, Mum sent me there to buy cheese and the lady asked if I wanted red or white, so I told her that I wanted yellow! She didn't laugh at me, she just showed me two different types of cheese and asked me which one

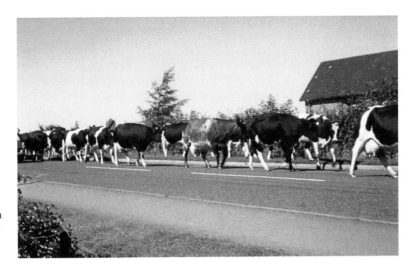

Cattle walking along Berrywood Road past Duston Secondary School in 1966. (© Sue Hoggarth)

I wanted. There wasn't a chemist until a shop which became Shepherds Chemist was built next door to Law's in 1960s.

Berrywood Road was a country road beyond Duston Secondary School and St Crispin's Hospital farm was further along the road. We often went to the woods to pick bluebells in the spring. Sometimes we walked further along the road to the farm, there were sheep or cattle in the fields and further on was a poultry barn.

A herd of cattle were driven along the road past our house regularly – they came from a nearby farm. It's hard to imagine cattle wandering along Berrywood Road now, it has become a very busy road.

Sue Hoggarth

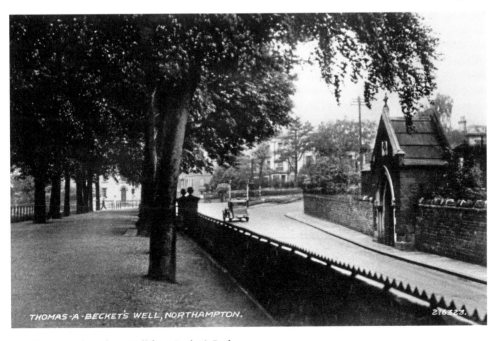

Looking towards Becket's Well from Becket's Park.

When we moved to Berrywood Road we were remote from the village. I felt isolated and I missed having children to play with. It was lovely to have the field to play in but I missed Becket's Park; it was a long walk to Errington Park and there wasn't much there back then. Sometimes sheep got into the gardens, it wasn't unusual to find a lamb wandering around the garden and once a cow got into a neighbour's garden. It was eating all their vegetables and it was comical to see the man and several children trying to chase it back into the field!

Sue Hoggarth

The shops at Kings Heath provided everything we needed – a chemist, a newsagent, an off-licence, two greengrocers, two butchers, a Spar, a Co-op, a wool shop and a fantastic little bakery. We bought paraffin for our heathers at the hardware store because we didn't have central heating. There were two pubs in Kings Heath, the Silver Cornet and the Morris Man. The Morris Man became a nightclub called Fantasia but I didn't go there, when I was old enough to go out the Salon in St James was the place to go.

We loved Harlestone Firs, which was within easy walking distance across the fields. We went there with our friends and sometimes we were out all day with only a container of water. We often walked there with our parents on Sunday afternoons too. Kingsthorpe Mill was a wonderful playground for children, it wasn't far away and we loved to go there to paddle in the water. The area was totally different then; we still had the old road which flooded so easily in bad weather.

Carol Grammer

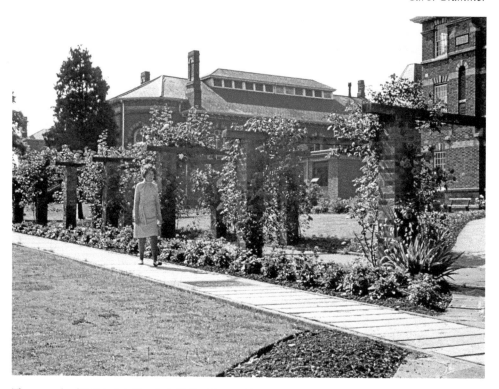

The grounds of St Crispin's Hospital. (© Sue Hoggarth)

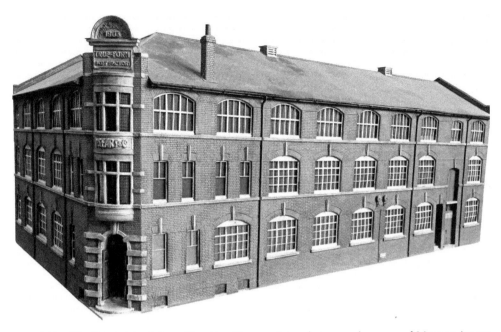

A model by Clive Hardwick – J. Sears 'True-Form' boot and shoe factory on the corner of Stimpson Avenue and Adnitt Road. The original was built in 1903, designed by J. Ingman of Wood Street, and built by A. P. Hawtin of Colwyn Road. (© Clive Hardwick)

There were shops on every corner so we could buy whatever we needed without going into town. People shopped almost daily so they didn't have to carry heavy bags. When we went to the butchers, he often gave me a few sheets of white paper to draw on. I drew maps and roads on the paper and then if I stuck the pieces together I had roads for my toy cars.

You could buy fireworks from local newsagents in the weeks leading to up to 5 November. They sold boxed selections and individual fireworks; bangers and jumping jacks were very popular with the boys. I remember buying caps for our toy guns, they were little rolls of paper with dots of something or other which made a very satisfying shooting sounds when loaded into the gun.

Clive Hardwick

1970s

The Mettoy factory was at the end of our street and there were always stray plastic balls around, maybe they were left behind when the staff played football in the yard.

The Express Lifts tower was built when I lived in St James. It was just off Weedon Road but it seemed as if it was at the end of our street. Dad and I watched it rise gradually as they were building it.

We used to shop at the Co-op on 'Jimmy's Square' and Dad took me and my friends to the library, which was above the National Westminster bank on St James Road.

Gayle Law

1980s

When I was about five I was allowed to go over the road to the shop with a note from Mum saying what I wanted. They would get the things that I needed, give me the correct change and I would go back across the road to Mum.

When I was about eleven I was hit by a van while crossing Broadmead Avenue on my way home from school. It wasn't my fault, the van was speeding around the corner where Broadmead joins Grange Road. I had looked before crossing but the van came out of nowhere and hit me. It threw me across the road and I had to go to hospital. There were a number of accidents near that corner. When I was younger a car lost control on the corner, hit something on the other side of the road and headed straight for us on the pavement. Dad managed to throw me and my friend over the hedge but several cars were damaged.

We bought a lot of our food from the shops on Broadmead Avenue. Mum liked the butchers and I still remember the earthy smell of the greengrocers shop. Mum often sent me to buy a few potatoes for dinner and the bags seemed to get heavier as I walked home. We used the post office a lot because we had savings accounts there. I loved the hardware shop, it had everything we needed. He mixed paint to whatever colour we wanted and he was very helpful and knowledgeable. There was a Co-op on that row of shops, but it closed a long time ago. If I did my jobs I was given some money on a Saturday and I went to the newsagents to spend it. They sold toys and games and I spent ages deciding what to buy. We understood the value of money because we didn't have a lot.

Tracy Webb

1990s

Before I was old enough to go to town on my own I was allowed to go to Weston Favell Centre with a friend. I liked places such as New Look for clothes and Superdrug for makeup. I loved WH Smith for CDs and books, I could have spent hours there choosing books.

Emily Jones

We often used the shops in Broadmead Avenue, especially the post office. Mum often went to the hardware shop for photocopying or pet food, they seemed to sell everything. Nearly all the shops that we used to have are gone now because they built a supermarket nearby that took their trade away. The shops are occupied again, but there is nothing that I need.

Laura Jones

I remember we sometimes walked to Weston Favell Centre via the walkway overpass at Weston Favell. Au Natural was an interesting shop and there was an Adams clothes shop; Mum bought a lot of my clothes there when I was young. I liked Choices video shop on Kettering Road. I recall the 'be kind, rewind' slogan, and how when DVDs came out, we were shocked because we didn't have to rewind them! Choices was a bit of a treat, I loved the experience of choosing a film for myself.

Sam Jones

Food and Shopping

1940S–1950S

We were given cod liver oil and orange juice, which we had to get from the fish market. I loved the orange juice, it was concentrated and it had to be diluted with water. Everything was rationed, even butter, so we needed the cod liver oil and orange juice to keep us healthy.

Yvonne Bodily

As kids we had to go blackberrying, we got the bus over to Gayton and picked big bagfuls of blackberries. My Mum bottled them in Kilner jars. It was the same with any fruit or tomatoes, everything was preserved and saved for the lean months of winter. There was still a war-time mentality in the 1950s, rationing was still on and nothing was wasted. People took care of what they had and they always kept a stock of supplies just in case it was needed.

Roger Broome

1950S

I remember buying a tiny Hovis loaf the size of small bread roll from the bakers on Regent Square which Mum sliced for us. Kings Heath shops were great, we bought a lot locally. Mum sent me to the Co-op on Saturday mornings with a list of things to buy. We all had a Co-op number to quote when paying. We went to Harry Brown's in the fishmarket to buy half pints of winkles, faggots and chitterlings for supper. Sunday roast meat had to last two or three days.

Gill Felton

A mobile shop in Berrywood Road 1966. (© Sue Hoggarth)

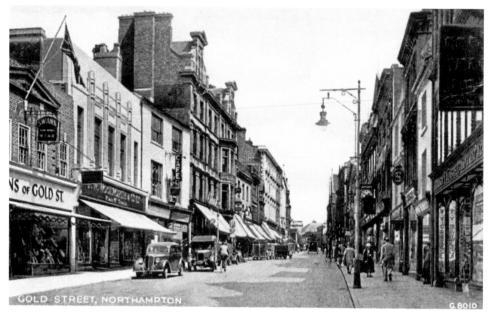

Gold Street looking towards the town centre.

1950s–1960s

Mum and Dad drove into town to do their food shopping on Saturdays. We were just starting to get supermarkets; there were a number of branches of Civils but Sainsbury's on Abington Street was the first big supermarket. We had Victor Value in Gold Street which later moved to the Market Square where the Peacock Hotel once stood.

Clive Hardwick

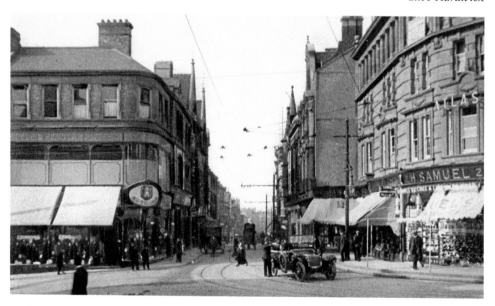

Looking down Gold Street with Bridge Street on the left.

When I was young Mum used to take me to Fontana's in Gold Street for lunch, that was our treat on Saturdays and sometimes I could choose a Knickerbocker Glory or a banana split.

Tracy Webb

It was nice when Safeway opened on the Kettering Road because they were a bit different. They had self-scan readers to scan your shopping as you went around the store. It was much easier and you could buy green crates which fitted in the trolley, making it much easier to pack your groceries.

Emily Jones

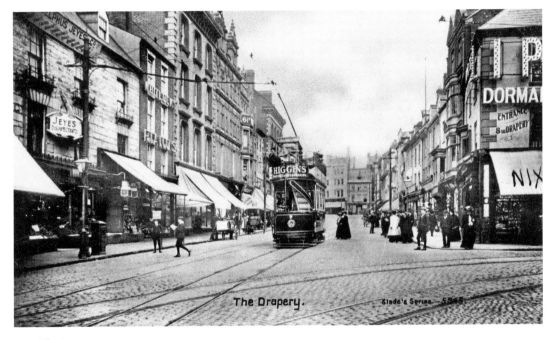

The Drapery.

Childhood and Play

1940s

I read the *Dandy* and the *Beano* until I grew out of those and moved on to the *Girl* comic. My brother liked *Topper* and the *Eagle* comic.

Yvonne Bodily

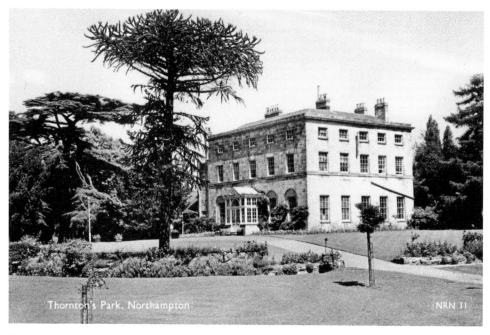

Thornton Park, Kingsthorpe.

1940s–1950s

We moved to Balmoral Road in 1948 when I was five. The fun in my life started there because I hadn't previously had many friends play with. After breakfast, I went out until teatime with just a bottle of tap water. I don't ever remember going home for dinner! We played in the street or we went to Thornton's Park, where we set up make-believe homes or shops among the trees. We went to Kingsthorpe Mill, stopping off for a cool drink at Kings Well near Kingsthorpe Village Green, it tasted better than the warm water in our bottles. Kingsthorpe Mill was a wonderful place, we paddled in the water and played with the children who gathered there from all over town. After that we walked through the fields to Walkers Mill further along the Welford Road. Part of the mill remained and we played in the old building or paddled in the water. Then we made our way home, stopping at the Kings Well again on the way. Sometimes we walked to Harlestone Firs to play hide and seek or to spot the various birds and animals.

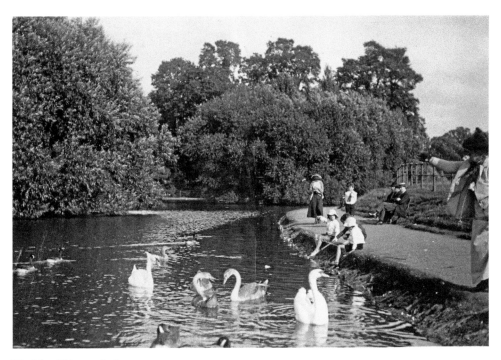

The lake, Abington Park.

My evenings were spent reading, doing French knitting or playing with Mum's button tin. It was always a quiet game so that Mum and Dad could listen to the radio.

Wendy Simpson

1950s

Once our parents were happy that we could cross main roads safely, we were allowed a lot of freedom. We roamed into Delapre Park, up the London Road Spinney and across the fields towards Hardingstone where we spent hours making mud dams in the spring streams and playing in the woods. My other favourite places included the swings and slide on the Recreation ground (where I lost my two front teeth at the age of six); the railway bridge and tunnel up Rothersthorpe Road, Danes Camp, and the Banks. The Banks was the area west of Airflow Streamlines between Briar Hill farm, the railway line leading up to the tunnel, the railway line to Blisworth and Leah's Bank, including the old lock-keeper's house and canal locks.

Visits to the Banks became a regular event, later extended with a visit to the loco shed as Sunday was the only day they let us roam the yards without getting thrown out. Saturday outings to the Banks were frequent in summer and any evening when it was not raining. We would run down Main Road from primary school at lunchtime to see what trains were running and we were sometimes late back for school as they were not always on time! On other days, we crossed the road from school and took the path leading to the footbridge to the loco shed to watch the engines passing and entering the sheds. We could play football between the cow pats in Beasley's field or cross the Blisworth line and play around the lock-keeper's house (later derelict) on the far side of the canal lock. We ventured over Leah's Bank towards the Cut (South Nene) and the

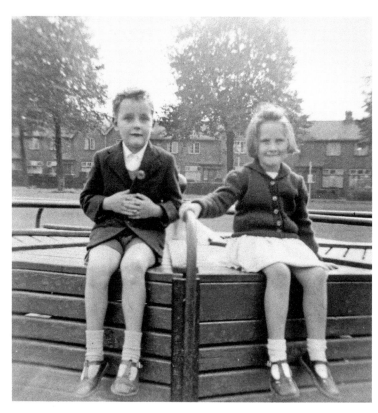

Far Cotton Recreation
Ground, late 1950s.
(© Sue Hoggarth)

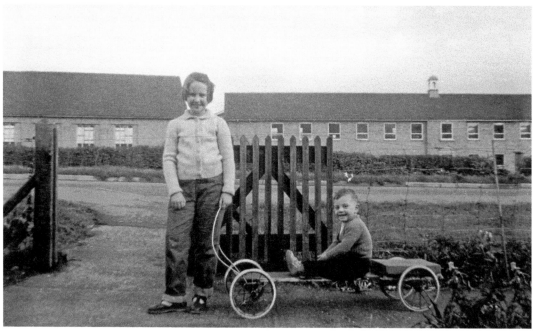

Playing with a go-kart opposite Duston Secondary School, 1961. (© Sue Hoggarth)

'Fifteen Arches'. This was a fabulous playground for us as pre-teens and it later became a regular haunt of trainspotters and Cottonites.

We took many risks and I am amazed that we survived, although I suspect there were some casualties in the canal and I recall a polio scare warning swimmers to stay away, and a death on the railway north of the Rothersthorpe Road Bridge one winter morning. In the winter of 1954/55 there was a long cold spell with snow and heavy frost. Far Cotton Junior School was closed so some of us went to the canal. It was frozen and despite many creaking noises no one fell through the ice as we continued our journey to the locks at the end of the canal near South Bridge, and then home.

Colin Skears

When I was young I pushed my dolls pram around the square but mainly we just ran around. Mum kept some old clothes for me to dress up, but I had two shop bought outfits, a cowgirl costume and a nurse's uniform. When I was a bit older we played 'letters in your name' or 'farmer farmer'.

Sue Hoggarth

1950s–1960s

When I lived in Grafton Street during the late 1950s, we played where the buildings had been demolished around Fitzroy Terrace; we had great fun among the rubble. I felt honoured to be given a 'sugar sandwich' by another mum. Kings Heath became our home in September 1960. Our house was in a newly built street near the countryside and the cornfields provided wonderful play areas for us to roam free. We walked to the firs, picked wild flowers and blackberries and had a picnic of jam or cheese sandwiches and water. We played games together in the street and we only went home when we felt hungry or it was getting cold and dark.

Gill Felton

1960s

Most of my friends lived nearby so we called for each other and played in the park or in the neighbourhood. I lived in Abington Avenue and the County Ground was one of our playgrounds. It was used for football in winter and cricket in summer. It was usually open and people walked through from Abington Avenue to Adnitt Road or Wantage Road. A lot of kids played there, we climbed up the railings and played hide and seek on the stands. We watched the Cobblers training, it wasn't really a public area but no one seemed to mind us being there. After matches we went around picking up the change dropped from people's pockets. We could collect two or three shillings in odd coppers, which was more than enough to buy sweets for a week.

My parents never set any boundaries in terms of where I could go. I had a bike from a young age and by the mid-1960s I cycled for miles around with my mates so we knew every nook and cranny of the town. We only had small bikes, I didn't get a big bike until I passed my eleven-plus exam and went to the grammar school. Many of the roads had alleyways behind them and we could have probably gone a long way without going near a main road.

Clive Hardwick

1960s–1970s

I lived in Kingsthorpe when I was a child. In the summer holidays we walked down to the Front, popped into Chris Sales to buy fishing nets, and walked down to the mill. We spent many happy hours there, fishing for tiddlers and tadpoles or just paddling. On the way home, we walked up High Street to the chip shop towards the top of the street. A bag of chips, a handful of batter bits and we were happy.

Mary Grant

1990s

I always played outside when I was with my childminder in Abington because it was very safe. Usually at least half a dozen children played outside, we rode bikes, played games or kicked a ball around. Sometimes we sat on the grass and made daisy chains or chatted to some of the elderly people living nearby. There were always people around to keep an eye on us.

Laura Jones

I loved going to 'The Quarry' in Duston with friends. We wouldn't use the small park section, but there was grass to play football and lots of trees and hills where we would play 'tracking' for hours.

Lewis Godbolt

Abington Park lake, 1966. (© Sue Hoggarth)

Parks

Abington Park

1940s–1950s

Mum took us to Abington Park during the school holidays. We packed sandwiches and spent the day there. The playground seemed bigger then and the rose garden was beautiful. Between the parks, there was man with a telescope and it cost a penny to look through it. We always visited the aviaries and we loved to run up and down the mound.

Yvonne Bodily

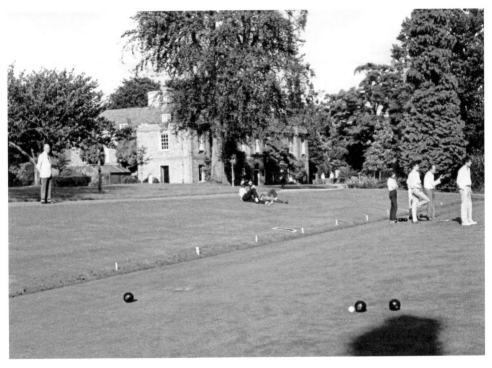

The bowling green, Abington Park, with the museum in the background. (© Sue Hoggarth)

1960s

Abington Park was our playground. We played football and when we tired of ball games we went to the lakes or built dens by the stream. Sometimes we went into the museum in the old Manor House; there were a few scary items but it was interesting. We visited the aviaries and we scrambled up and down the mound. There was a boating lake and a pitch and putt course too.

Clive Hardwick

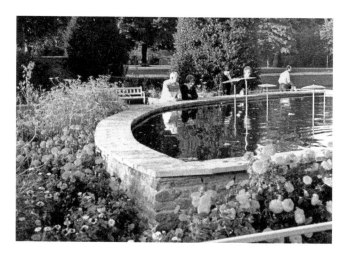

The Garden for the Blind,
Abington Park.
(© Sue Hoggarth)

1990s

I loved Abington Park. The playground had a brilliant spiders-web roundabout and everyone loved the train. We often bought an ice cream before visiting the aviaries to see the peacocks and we played on the mound, ran around the bandstand, fed the ducks and splashed in the stream.

Emily Jones

We always went to the lake to feed the ducks in Abington Park. There was a big wooden train in the play area, which everyone loved, but eventually it was destroyed by fire.

Simon Hoggarth

I loved the playground; there were swings, a big slide, a tractor-shaped climbing frame and a train but I liked the roundabout best. We fished in the stream, fed the ducks, explored the spinney and Grandad showed us the garden for the blind with interesting sounds, smells and textures. I wondered if anyone lived in the house near the bowling green where we sometimes watched Uncle John play bowls.

Laura Jones

The train, Abington Park 1991.
(© Sue Hoggarth)

The Mulberry tree, Abington Park. (© Sue Hoggarth)

The Racecourse

Dad told me that it was an army camp in the war and Grandma remembered the army camp in the First World War, when they had tents rather than buildings and there were more horses than anyone could count. When she was a girl, it had been a real racecourse but racing stopped in 1904.

Christine Jones

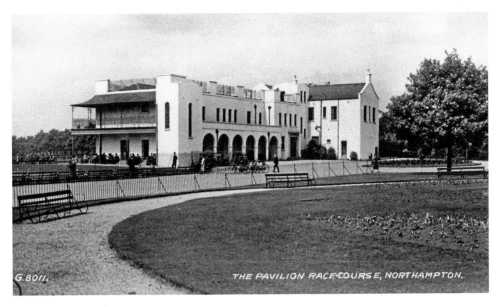

The Racecourse Pavilion.

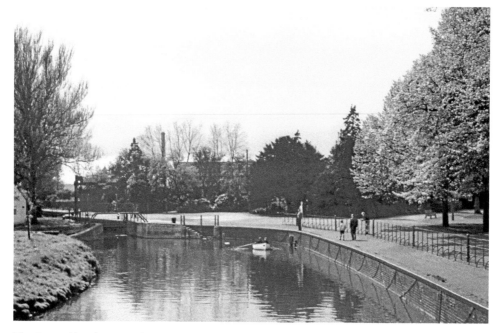

The river and boathouse, Becket's Park. (© Sue Hoggarth)

Victoria Park

1950s

There was a big wooden building in Victoria Park known as 'the old man's hut'. It was a social centre, the men smoked, chatted and played whist and dominoes. Grandad went there for company when he stayed with us. There were grass and hard tennis courts and a well-kept bowling green. The trainspotting bench was popular with local children as well as the stream and playground and a park-keeper kept everyone in order. There was also a nursery school in the park.

Brenda Broome

The lads were at Victoria Park every day in summer playing cricket or football. Trainspotting was especially good on weekends when maintenance work forced all traffic to use the loop through Northampton. We had our Bible class in the park on summer Sundays! On Sunday afternoons in our late teens a dozen of us played 'old men's marbles' (bowls). It cost a penny to hire the covers for your shoes and you had to hire your woods, the mat and the jack.

Roger Broome

1970s

Sometimes, we played rounders in the park and I played in the playground or looked for tadpoles in the stream. Once I fell off the rope swing near the playground and landed in the stream. I enjoyed watching the trains from the trainspotting bench with Dad.

Gayle Law

Becket's Park Recreation Ground. (© Sue Hoggarth)

Becket's Park

1940s

I went to Becket's Park a lot when I lived in Victoria Gardens. We knew it as 'the meadow', it was a lovely park.

Yvonne Bodily

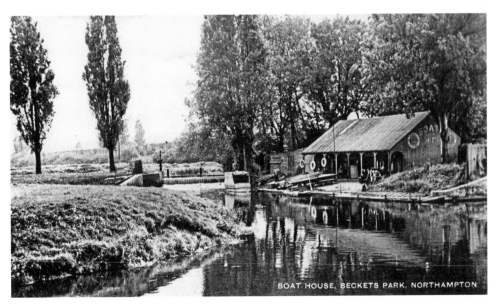

The Boat House, Becket's Park.

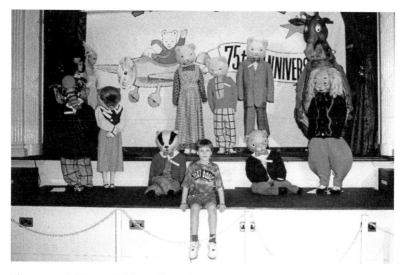

The Rupert Exhibition, Wicksteed Park, Kettering. (© Sue Hoggarth)

1950s

We went to Becket's Park most days. I ran around, played games, watched the boats, went to the play area and then Mum often bought me a lolly at the cafe in the park.

Sue Hoggarth

Kingsthorpe Rec

We lived near the Rec in Kingsthorpe. I liked the 'jazzer' in the playground. It was a long piece of wood mounted on a frame to swing from side to side and sometimes the boys made it go too high.

Yvonne Bodily

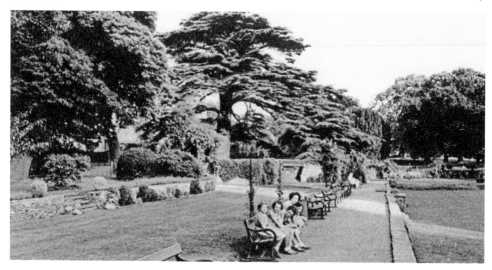

Thornton Park, Kingsthorpe.

Wicksteed Park

(Not quite Northampton but loved by everyone.)

1990s

We visited Wicksteed often in the summer and we usually took a picnic. The massive play area with swings, curvy slides, fireman's poles and climbing apparatus was brilliant. I enjoyed watching the potter and the glassblower working in the little shops. We bought a sheet of tickets for the rides and used a few on each visit. I liked the go-kart track, the ladybird roller coaster, the ride on motorbikes and the train that went all the way around the grounds.

Emily Jones

We often went to Wicksteed Park and I loved the playground. I liked the little cars, my dad went on the same cars as a child. The pedal helicopter ride was fun and I liked the water chute, which was another old favourite that my parents remembered. They had a Rupert Bear's seventy-fifth anniversary exhibition in the banqueting hall, where they performed plays and memorabilia was displayed showing Rupert through the years.

Simon Hoggarth

I went to Wicksteed Park for my birthday one year and fell in the boating lake! I was kayaking with a friend and I tried to jump onto the bank but it didn't end well. I enjoyed the pirate ship ride.

Lewis Godbolt

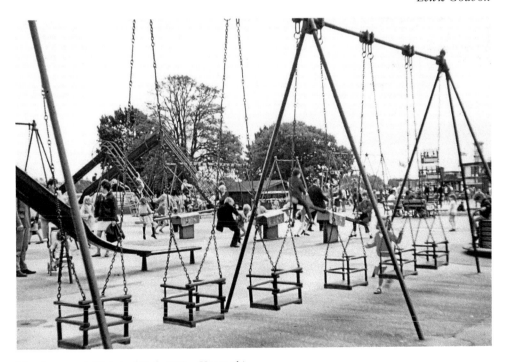

The playground, Wicksteed Park. (© Sue Hoggarth)

Education

1930s

Mum went to the 'tin school' near the corporation bus depot on St James Road. It was nicknamed the 'tin school' because of its construction. In those days if you went to St James Church you were able to go to St James Church School, but if not you had to go to the 'tin school'.

Brenda Broome

St Mary's School was very strict, and a few of our teachers were nuns. It was very much 'girls should be seen and not heard' and we had to sit very still with our hands in front of us. I was a Baptist but St Mary's was our nearest girls' school and my parents wanted me to go there. Occasionally we went into the Notre Dame grounds, but not often; there wasn't much connection between the two schools. When we took the eleven-plus, there were a few 'Sister Mary's' places for girls at our school to go to Notre Dame. My friend got a place, but she couldn't go because her mother couldn't afford the uniform.

I was happy there, they were kind and encouraging in the infants and Sister Austin was like a saint but the junior school was stricter. Sister Magdalene was alright but then we had Sister St John and I don't think there was anyone else like her! She went red in the face and stomped around and sometimes she got so angry that she looked as if she was going to burst, it's a wonder she didn't have a heart attack. It wasn't unusual to get a slap on the hand with a wooden ruler.

We didn't wear a uniform, we wore our own clothes; there were some poor children at school who really didn't have very much at all and you could see the difference in what they wore. We studied the catechism and we were taught a lot about Roman Catholic beliefs. They celebrated all the saints' days and we were given picture cards to slip into our bibles. Other schools had a

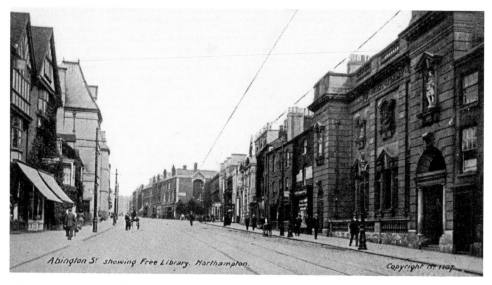

Abington Street with the library on right.

Bible reading every day but we had the catechism so we knew more about the Catholic beliefs but less about the Bible.

More nuns came with the evacuees in the war. I didn't lose any time at school because I was ready to leave, but for a while my younger sisters only went to school for half days because the evacuees shared the school. My sisters said that some of the evacuees were badly behaved and the nuns were very strict with them. I didn't see it but I was told that they used to take the belt to some of the children.

Joan Clarke

1940s

I went to Victoria Park nursery. During the war, children went to nursery school and the mothers worked in the factories. Mum took me on the back of her bike in my siren suit. I was there all day. It wasn't too bad, we had toys to play with and we had our meals there. I remember eating junket, which I quite liked. The teachers were strict and they smacked you if you were naughty. I hated getting up early in the morning to go out in the dark to get there. During the war, the clocks were two hours ahead of GMT in summer and one hour ahead in winter to save daylight.

I went to Saint Mary's School on the Mounts. They were strict, but on the whole I liked it. I wasn't a Catholic but my experiences at school led me to have instruction to become a Roman Catholic.

Yvonne Bodily

My first day at Kingsthorpe Grove Infants School was overwhelming as I had been to a small school in Semilong called St Pauls for a year. Kingsthorpe Grove had a lot more children in the class. We had assembly in the hall every day and we sang hymns and said the Lord's Prayer. We used an abacus to count, flashcards and pictures to recognise words and we sang nursery rhymes and songs. By the end of the year I could count, write and read books about John, Jane and Rover the dog. We had our sports day in June, it was very exciting to go home wearing a winners' ribbon. The following year Bective Infants School opened and a lot of my friends moved there so we had

The Mounts, Northampton NRN 12

The police station and fire station, Campbell Square.

smaller classes. During the year my reading and writing came on in leaps and bounds, my arithmetic improved and I learnt to tell the time. I joined the library and developed a passion for reading.

At junior school we studied more subjects, including history, geography and art. I always came top in history and I went to Kingsthorpe library to research anything that interested me. Our headmaster was strict but he was a nice man. One day he showed me a photograph of my dad. He said that Dad was the best local footballer and should have played for the Cobblers but he only played one game because my grandfather stopped him.

In the final year at junior school we took the eleven-plus examination. The winter seemed very long; we made ice slides in the playground and had fun until our caretaker put salt on them. I knew my parents couldn't afford the uniform if I passed the eleven-plus, it would have meant going into debt so I thought it would be better if I failed. No one passed so most of the boys went to Bective and the girls to Kingsthorpe School for Girls.

When the new term started we had moved house to Rosgill Place in Eastfield but I went to Kingsthorpe School for Girls. Mum bought an old sit-up-and-beg bike for me to ride to school. It was a long journey down Broadmead Avenue, across the Kettering Road, down Kenmuir Avenue, through a field which later became Fairway onto Kingsley Road and up the hill to Kingsthorpe. In the winter Mum bought me a bus pass, it meant two buses but it was worth it to stay with my friends.

We had to wear a white blouse and navy knickers for gym, even in the winter. We played netball and hockey but I wasn't good at sport. The headmistress was very stern and everyone kept out of her way. If we broke the rules, we were given a detention and had to write 100 lines – for example 'I must wear my beret' or 'I must not talk in class'.

The wider range of lessons included science, drama, needlework and domestic science. We went to Kettering Road boys' school every Monday because there wasn't enough room at our own school. We had assembly in the hall every Friday, the BBC had a program with hymns and prayers, we listened and sang along with the hymns. I still loved history and I took an interest in geography. I made an apron and a blouse and I baked a Christmas cake as well as learning to cook many other things. All of us cooked well. I belonged to the school choir and every Christmas we put on a show with the drama group.

My school work declined in my final years as I became more interested in music and dancing but I was sad when the day came to leave school. It felt as if we were stepping out into the unknown, taking the first step into our future lives.

Wendy Simpson

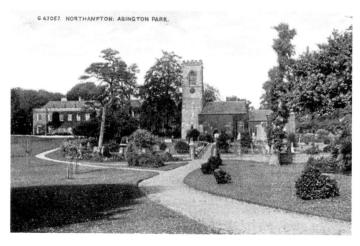

The Church and Manor House Abington Park.

My daughter passed to go to the grammar school. It was very strict but they got good results. It was on St Georges Avenue. It had a navy and white uniform but it changed to grey and blue in my daughter's first year. I preferred the navy and white, with the navy blazer edged with blue and white stripes all the way round.

Joan Clarke

I was born in 1946 and I lived in Delapre Crescent Road, Far Cotton. My brother and I went to Far Cotton Primary and Junior Schools before taking the eleven-plus and moving on to the Technical High School, which later became Trinity High School.

We were allowed a lot of freedom of movement. After being taken to school by my mother on the first day at primary school in 1952, I was then taken by my brother until I was confident enough to go alone or with friends.

Thanks mostly to a teacher at Far Cotton Junior School, I 'sort of' passed the eleven-plus. Initially, I was accepted for Trinity High School but later I was offered a place at Northampton Grammar School. As my brother was already at Trinity it seemed best if I followed in his footsteps, wearing his hand-me-downs. Initially we had to bus it, but later we cycled to school. We went home for lunch as school meals were everything that history has made them out to be and, excepting washday on Mondays, Mum had time to cook for us. My early years at Trinity were unremarkable and although I was always in the top class for the year, I was in the middle of the class as I found most lessons of little interest. The only exceptions were Physics and Geography, which held my attention.

Colin Skears

When I was at St James School, the children walked to St James Institute for their dinner. Fewer children stayed for dinner in those days because we had two hours at lunchtime. We stayed later in the afternoon, the infants finished at 4 o'clock and the juniors half an hour later. During my

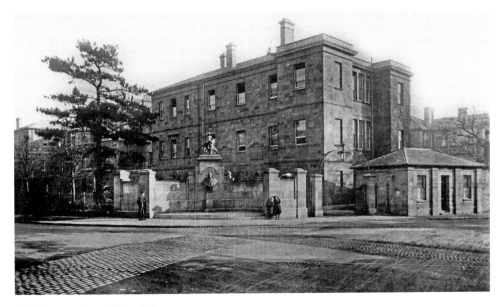

Northampton General Hospital.

time at St James school we used to go to the Institute to do our end of term concert, because the school had nowhere big enough accommodate everyone. Lots of things took place at the Institute: Grandma went to a Darby and Joan club and lots of groups such as Brownies, Guides and Scouts met there. It was connected with St James Church.

During my first year at Spencer School, a summer uniform was introduced and on 1 June all the girls wore their spotted dresses. At lunch time, my friend and I decided to go through Victoria Park to see if we could get some tadpoles but I fell in and got drenched. Mum was furious and in the afternoon I had to wear my navy skirt so I got told off at school as well!

Brenda Broome

I went to All Saints' Voluntary Primary School, which I think was in Woolmonger Street or Horseshoe Street. It was very old and was on the verge of closure when I went there, we moved away in 1957 and it closed in 1958. It was heated by a big old stove with a guard around it. There were only four teachers with four classes for all the children, so we stayed in each class for quite a long time. We were divided up into ability groups within each class. They soon had us reading and we chanted the times tables every day. Children couldn't move into the next class until they could read confidently. Physical punishment such as being slapped on the legs was not unusual. There was a large assembly hall and girls and boys were separated in assembly. I enjoyed assembly because we sang hymns and the headmaster played the piano for us.

We had a lesson called 'drill' which took place in the hall. It was a bit like PE, but we did exercises and we played some very old-fashioned games such as 'the Farmer's in his Dell' and 'Jenny Sits a-Weeping'. We did painting and crafts, I remember making little paper lanterns at Christmas. We did weaving with strips of paper and sometimes we were given a piece of cardboard to colour and use as a milk mat. I liked music lessons, especially when we were allowed to use the instruments but it made me angry that only boys were allowed to play the drums. We were told that girls didn't have drums, but I longed to play the drums. Years later when I reached secondary school, I found that the choices for girls were restricted. Woodwork, metalwork, technical drawing, physics and chemistry were only open to boys.

I went to Duston Church of England Primary School. The headmaster said I was too far ahead so he put me in the next class. Mum had dressed me in the way I sometimes dressed for my other school. I wore a navy skirt, white blouse, navy hand knitted cardigan and a tie. One of the girls pointed at me and said "look, she's a boy, she's wearing a tie" then the other children laughed and called me a boy. I was the only child wearing uniform, the other girls wore their own dresses.

Duston Secondary School, 1966, from the front garden of the council house opposite. (© Sue Hoggarth)

After that I was the odd one out and I wasn't very happy at school; I could cope with the work, the children were the problem. My first teacher was nice but my next teacher was horrible and I would cry and feel sick because I didn't want to go to school.

Like my previous school, it was an old building with outside toilets. It didn't have a hall, so we used two partitioned classrooms with the partition pushed back and for assembly. We could only do PE in dry weather because we did it in the playground. It was very unfair because the girls were made to do PE in their knickers but the boys were allowed to keep their shorts on. We used the partitioned classrooms for concerts and plays. In my final year at primary school, additional classrooms and a big playground were built behind the school on land from an adjoining property.

We all sat the eleven-plus – it was compulsory. I passed to go to the grammar school, but Mum didn't want me to go. She said there was a school opposite our house and it would be more convenient for me to go there. The headmaster wrote to urge her to let me go but she refused. The cost of bus fares would have been a worry for them as well as the cost of uniform.

Sue Hoggarth

I went to Spring Lane Infants School, where the rooms had fire places and wooden floors. The teachers seemed very old and I missed my mum. Kings Heath Junior School was perfect. I loved my days there, it was five minutes' walk from home in a beautiful setting with a playground overlooking Kingsthorpe village. It was a new modern school with many younger teachers. St George's Secondary Modern school was very different; it was ancient but it had a 'homely' feel. It was a girls' school, we studied all the main subjects: maths, English, geography, history and religious instruction but my best lessons were cookery, sewing, art, shorthand and typing.

Gill Felton

After a while at Kings Heath Junior School, I took the eleven-plus. I had a terrible headache on the morning of the exam and I took painkillers, but looking back I realise that was not a good idea as it was borderline whether I passed or not. I failed and I blame the tablets! The schools left open to me were Spencer, Campbell Square, Cherry Orchard and Delapre. Mum applied to get me into Cherry Orchard, but I was not offered a place because we lived too far away. Spencer and Campbell Square had bad reputations so I ended up at Delapre. I had to catch two buses, but I soon got used to it and I liked my time there.

Michael Cunnew

1950s–1960s

On my first day at Spencer Infants School I was stung by a bee at playtime, so I went looking for my sister in the juniors. When I reached the hall via the playground gate that split the school areas, I came slap-bang upon the headmistress who went raving mad at me. She didn't check the finger I had clutched in the other hand but sent me packing back through the gate into the other playground, telling me to go back inside. My tears meant nothing to her. I didn't go back – if I couldn't have my sister, I was going home to show my mum. I walked, aged just over four, from the school along past the park, through Dallington, over the road and up the hill into Heathville to get home. Needless to say my mother was livid about me walking the streets like that and no one at the school knowing I had gone. She removed the bee stuck to my finger where I had squashed it with my other hand and treated my finger. Then I was left with a neighbour and

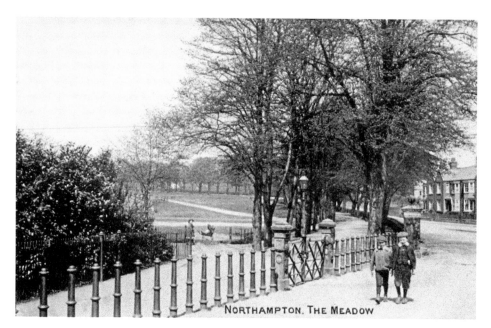

NORTHAMPTON. THE MEADOW

Becket's Park.

I don't know what happened, but on the following day I started at Kings Heath Infant School, where I remained until we moved to Herbert Street.

The majority of my early years of schooling, infants and juniors were at Spring Lane School. I have many happy memories of the time I spent at Spring Lane. In the juniors we all had to write a play and they were to be looked at by the headmaster, who would give a prize to the best one chosen. It was mine and I received a big bar of chocolate; I was so proud to take it home to Mum. I remember it was the first time she said I didn't have to share it, but it was so big I did anyway. I was even prouder when my play was used for the school. I had to tell people where to stand and how to do things. I loved that!

Sue Hardwick

1960s

I went to Kingsthorpe Secondary Modern School for girls. I always remember Gladys Aylward coming to the school in the 1960s to talk about her life as a missionary. I used to serve the staff their school dinners and it meant that we got to eat better meals than the other girls. I also remember being at school when the Cuban Crisis between America and the Soviet Union in 1962 meant we worried about whether there was going to be a war.

Sandy Hall

There was an infants and a junior school in Kings Heath. All my school friends lived nearby so we played together after school. The infant school was up on the hill and Mum took us to school. The junior school was just round the corner from our home so we walked on our own. I sat the eleven-plus in my final year. The nearest schools were Spencer, Trinity and Kingsthorpe and I got into Spencer. I loved it there; it was an old building, but there was a great atmosphere and it was

connected to the boys' school, which had distinct advantages! Both schools were separated within the same building. I was in the top maths group, but during the first year of our CSE course our maths teacher left and she was not replaced, so the headmistress reluctantly allowed us to have mixed maths lessons. We had to go to the boys' school, which was an incentive to remain in the top group.

Carol Grammer

I went to Duston Secondary School in 1962. The school opened in 1956. Previously, children attended the village school until they were fifteen unless they passed for the grammar school or the technical school.

I thought it was wonderful to have a modern building with indoor toilets, a hall and gym. Test results determined which class we were put in. Most years had four streamed classes, but my year had three classes. I was in the top group. The headmaster was strict and traditional, he made no allowances for children with learning or developmental problems and it was not uncommon for children to be called stupid or lazy – or even to be made an example of in assembly.

The school offered GCEs but you had to stay for an extra year rather than leaving at fifteen. I chose to leave because I didn't like the school. It was a mistake because I didn't get any qualifications, but you didn't need qualifications to get a job then. I went into a job at Timken working in the office and no one asked if I had any qualifications. If you left a job you could walk into another the next day.

Sue Hoggarth

I went to Stimpson Avenue School until I passed the eleven-plus and then I went to the grammar school. Like other schools in the area such as St Matthews, Barry Road and Clare Street, Stimpson Avenue had been built as a board school in the 1880s or 1890s so it was an old building. They were all built in red brick and usually they had three strips of blue brick. They had huge cavernous classrooms with exposed tie rods across the roof space. There were big old-fashioned radiators and all the schools seemed to follow the same colour scheme of brown, cream and green. We had good teachers – I had a lovely time at school. There were two streamed classes per year group. There were forty-eight in our class with one teacher and no assistants. We had one teacher for everything, there were no specialisms.

I took the eleven-plus exam and twelve of us from Stimpson Avenue passed. Most went to the grammar school and a few to Trinity which was still seen by some as second-best because it had previously been a technical school. The big advantage it had was its co-educational status!

I started grammar school in 1968. I didn't mind some of my friends going to other schools because some came to the grammar school with me and we remained friends throughout secondary school. There wasn't much resentment towards me from friends who didn't pass, possibly because they moved to Cherry Orchard, which was also a good school. Several of the people from primary school who failed the eleven-plus came to the grammar school for sixth form.

We wore uniform and for the first two years we had to wear caps. On the last day of the second year we walked down Billing Road and threw our caps up to festoon the trees.

Clive Hardwick

1970S

"I enjoyed Gladstone School but I didn't settle at St James. I loved Spencer Middle School. There were four blocks, one for each year with two assembly halls. We had swimming galas

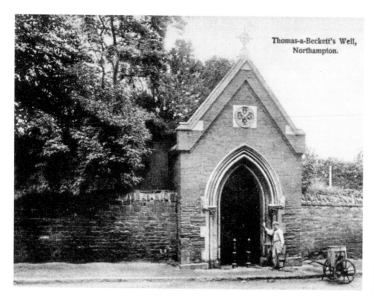

Becket's Well near
Becket's Park.

at the Mounts; there was a choir and an orchestra and we played at school concerts and other functions. The maths teacher was very strict and he gave us all 'clonks' if we made mistakes in our books. He threw board rubbers in the classroom if pupils weren't concentrating and I even remember him using the cane in class.

Gayle Law

1980s

I was happy at Eastfield Lower School. It wasn't far away and I walked to school on my own or with friends. I was taught to cross the road before I started school. The roads on the way to school were not very busy and there were fewer parked cars then.

Tracy Webb

1990s–2000s

I enjoyed my time at Headlands Lower School. The grounds were large with two playgrounds and a large field. Archways connected two buildings together and they still had outside toilets. Friday was the awards assembly, we celebrated everything at Headlands: birthdays, achievement, progress and success of any kind. Each class had an opportunity to lead an assembly each year and we were given lots of praise and made to feel very special. Every religious festival was recognised and celebrated, I particularly enjoyed the Diwali assembly. I enjoyed music and I was in the choir, recorder group and steel pan group.

One of the most memorable events was 'evacuation day'. As part of our Year 3 history topic about the war, we spent the day as evacuees. Even our packed lunches where restricted to food available at that time and wrapped in brown paper. The teachers were very strict like teachers at that time, which was terrifying!

It was a very good school and my friends from Headlands have all done good things with their lives. I loved the headteacher, she was terrifying at times but she was fair and she definitely

got things done. She was a positive role model. The headteachers at my other two schools were also excellent role models, they were very different but they were all inspirational.

Cherry Orchard was a big school with massive grounds. There were five classes per year group and we were split into four houses: Harvey, Thursby, Barnard and Wantage. The uniform rules were strict and we even had school rugby socks for PE. The headteacher insisted on shirts tucked in and ties of the correct length. The school was well resourced and there were areas within it for each year group; beyond the playground was a massive field and then a lower field surrounded by trees.

I loved the music room, there were keyboards available for people to work on and a storage room full of percussion instruments to experiment with. The gym was old fashioned with equipment that pulled out from the walls, including ropes, beams and vaulting horses.

The school had a good library and in Year 8 I became a pupil librarian. We were given a lot of responsibility and many pupils took on roles within the school. We had lots of people from other faiths but almost everyone went to assembly even though there was a Christian element to it.

In Year 8, I was in the accelerated learning class. The main advantage was being taught by the headteacher; he was a great teacher and he taught us far more than just history. He detested bad spelling and he gave us tips to remember words. We could all spell parliament 'because Liam is in it'. I had amazing teachers in Year 8, but he was my favourite. I think I was better equipped by my middle school than some people at my senior school. Our headteacher was particularly strict about essay structure and he insisted on neatly handwritten essays using a fountain pen or rollerball. At upper school we were allowed to do much more work on the computer.

I loved Headlands, but I think Cherry Orchard was my favourite. It was a happy school with a lovely atmosphere, but it was strict with clear boundaries. People with problems or sadness were supported very well and we were all encouraged to take part in extracurricular activities. It gave us time to grow in confidence before moving to upper school.

I went to Northampton School for Girls. I was lucky to get a place because it was massively oversubscribed. There were ten classes per year group so it wasn't possible to know everyone but a series of small communities within the school created a sense of unity. I really liked our headteacher, she was quiet and respectful of everyone but she was a strong leader. She had a clear vision for the school and she was a very good role model.

Almost all lessons were taught in class groups until GCSE options. The more collaborative and inclusive style of learning taught me valuable lessons. The school got excellent results but it wasn't elitist. Progress was recognised and praised as much as achievement and we were encouraged to develop our full potential as individuals, not measured against each other.

I did well, partly because middle school had equipped me with important skills. It was a relaxed environment – we were expected to take responsibility for ourselves, but there were sanctions if we didn't live up to that trust. We worked hard and we had lots of homework. The headteacher took every opportunity to tell us that if anyone tried to restrict our ambitions as women, we should work even harder to prove them wrong.

Emily Jones

I was just finishing middle school when they changed the school system, so, when I went from Ryelands Middle School to Northampton School for Boys, the two years below me moved up too. The new Year 7 and 8 pupils went to the Cliftonville site while work went on at the main site. NSB had building work going on for most of my time in main school. I was able to enjoy the changes in sixth form when everything was finished. I was sad to see Ryelands close because I really enjoyed the school. I don't remember much emphasis on the closure when I left, but a

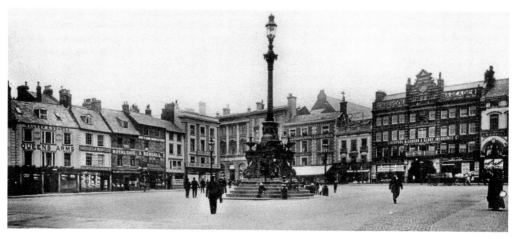

The Market Square and fountain.

whole school photo was taken and we were allowed to wear the summer uniform of a polo shirt rather than a shirt and tie all year – that was big deal to us!

Lewis Godbolt

I have happy memories of my time at Samuel's Nursery in Broadmead Avenue, the teachers were lovely and I was very sad when I had to leave.

Headlands Lower School was a comfortable and happy place. There were three classes per year and we were divided into groups within our class according to ability. We worked hard but learning was fun and there were lots of memorable events. Everyone learnt to swim at Headlands, our headteacher wouldn't give up on anybody and I enjoyed lessons with her.

We had assembly every day. My friend always got the giggles when we sang 'When I needed a neighbour' because it contained the word 'naked'. There was a lot of music and singing at Headlands. We had a wonderful teacher who could play the piano, lead the choir and teach the steel pan and recorder groups. I was sad to leave Headlands, but most of my friends were going to Cherry Orchard and I knew what to expect because I had a sister there.

I loved Cherry Orchard, it was strict but it was my favourite school. A standard was set from the beginning, the headteacher set out exactly what he wanted and he made sure that everyone knew what was expected. The school was built in 1950s as a secondary school, it was old but it had character and it was a very busy place with good facilities.

Year 5 was similar to lower school, we had the same teacher for most subjects. By Years 7 and 8 it was more like secondary school; we had specialist teachers for each subject and we were given much more responsibility. I was taught by the headteacher in Year 8, he was brilliant. He wouldn't tolerate people who messed around, he drew attention to them and told the class there was a 'pool of ignorance' on that side of the room. He was a stickler for the rules but he was very fair about it. There were clear sanction for bad behaviour and everyone knew exactly what was expected of them. I liked all the teachers at Cherry Orchard. Some were strict, but we had good teachers and we studied at quite a high level for Year 8. Geography lessons were very traditional with none of the kinds of geography we teach today, but the teacher was a legend, a nice man and a good teacher.

Our headteacher called an assembly to tell us that Cherry Orchard was going to close, he was upset and it was clear how much the school meant to him. It was devastating news. In the final year before closure, I was in Year 8 and there were no Year 5s so the school felt empty. It was

painfully sad and it made leaving the school even harder because we would never be able to go back and visit. You could tell that the teachers were very upset. Everyone loved Cherry Orchard.

My year would have left anyway, but when we moved to senior school the two years below us came too. For several years there were two sites and Years 7 and 8 were taught on the old middle school site. There was constant building work for several years as they rebuilt the school, block by block. The previous buildings were dilapidated, but the changes had a negative impact on our education. Timetables changed constantly so we never knew where our lessons would be and it was very disruptive especially during exams.

NSG wasn't as strict but it was a good school. The teachers were good and our headteacher was fantastic. I think it was the best upper school in Northampton. We were encouraged to develop our strengths whatever they were and I had some very inspiring teachers during my time at the school. My first science teacher was a legend, her enthusiasm was infectious. Her influence led me to choose triple science for GCSE otherwise I would have done German. I went on to study science for A level – my biology teacher was brilliant. She was nearing the end of her career but still had a passion for her subject. My geography teacher brought the subject to life – thanks to him I studied it at A level, university, and now teach it! I've had some very special teachers throughout my school life and several were a big influence on me.

After school, I moved on to Northampton University because they offered a very good geography course. I loved every minute of my time there. It wasn't difficult having the university on two sites because they invested a lot on transport and there was a frequent bus service linking the two sites together.

Laura Jones

I remember the seventy-fifth anniversary celebrations at Headlands Lower School as our headteacher dressed as Queen Elizabeth 1. She was a bit scary but she was very patient with me when I was learning to swim. An incident had badly frightened me but she encouraged me and never gave up; I think she was as pleased as me when I finally swam without armbands!

I was at Headlands when the middle schools were phased out. The year above me were the first year to remain at Headlands for Year 5. I felt cheated when I reached Year 4 and we didn't have the 'perks' and responsibility that Year 4 pupils usually had, because the Year 5 pupils were still at the school and it was the same the next year. I wished I could have gone into Year 5 at Cherry Orchard like my sisters, but I was stuck in what still felt like Lower School. I was deeply unimpressed to find that I was still wearing one of the only remaining sweatshirts with 'lower school' rather than 'primary school' emblazoned across it when I was in Year 6! Part of the quad was used to build more classrooms and the existing upstairs rooms were reorganised to provide better facilities for older pupils. It was nice to see the quad brought back to life afterwards.

Moving on to Northampton School for Boys felt like one big move despite being based initially at the old Cliftonville Middle School building. I think the change to the two-tier system harmed my education because we were not given room to grow and we definitely missed out on a range of opportunities.

During my GCSE year, I obtained a place at Northampton School for Girls for A levels. Many of my teachers were surprised by my decision, but my sisters did well there and it was a better environment for me. It felt like being among meerkats at NSG because there were very few boys in the sixth form and heads would turn because I was a curiosity, but they soon had decided that I wasn't that interesting after all! The school suited me very well, I had some good teachers and lots of encouragement. I think I was well equipped for university.

Sam Jones

Church and Sunday School

1920s

Dad was church secretary at Artisan Road Chapel. I went to the Sunday morning service with him, Mum stayed at home because my sister was just a baby. It closed soon afterwards and the building became a furniture warehouse.

Joan Clarke

The Roman Catholic Cathedral of Our Lady and St Thomas, Barack Road.

1940s–1950s

Sunday was a day of rest, we always had a fried breakfast and then I went to church. When I returned, my father and brother were waiting for me to visit my grandparents on Boughton Green Road. My dad took Pap to the Five Bells for a drink and my brother and I were sent to play in the yard with a packet of crisps and a bottle of pop.

Sunday lunch was roast beef or lamb with Yorkshire pudding. After lunch I went to Sunday school, and each week we were given a stamp with a religious verse. At teatime we had salmon sandwiches which Mum told us were made with the best butter, and there was always trifle. I went back to church for the evening service. My life revolved around Holy Trinity Church, I went to Brownies and various different social events there too. I was confirmed there when I was eleven. Sundays were very quiet, no shops were open, and there were no children out playing in the streets.

Wendy Simpson

Harvest Festival at Trinity Methodist Church, Wellingborough Road 1982. (© Sue Hoggarth)

1950s

When I was six the vicar from St Mary's Church called at home and asked whether my parents would like to send me to Sunday school, which they did, taking me the next Sunday. After that I was sent, under my own steam, for a couple of weeks before I decided that I had had enough. Not having the courage to tell my parents, I decided to go past the church and explore. So, I went down Abbey Road to the end and then onto what we later knew as the 'Tank Field'. From there I went diagonally towards the end of Main Road and onto the short track and bridge under the railway line to watch the trains from the field until I felt hungry. This worked well until about twelve months later when the vicar called at home to ask if my parents would like to send me to Sunday school! I received nothing more than a scolding and my visits to 'The Banks' became a regular event, later extended with a visit to the loco shed as Sunday was the only day they let us roam the yards without getting thrown out.

Colin Skears

I started Sunday school at Doddridge Memorial Chapel in St James Road when I was two and I progressed from pupil to teacher. In the 1950s all three of the rooms used for Sunday school were packed with young people. On the Sunday school anniversary we paraded round the streets with the Boys' Brigade Band and the Northampton Town Band, singing hymns on the street corners and inviting the residents to join with us for the church services. Sunday school outings were the highlight of the year – we went to Wicksteed Park, Warwick Castle, or to the zoo. Several red double-decker buses queued up in Marlborough Road to transport us all to our destination. Another highlight was the annual prize giving in October.

As teenagers we attended Sunday school in the morning and afternoon and returned for the evening church service and Young People's Fellowship afterwards. Brownies, Guides and Boys Brigade played a big part in the lives of us Jimmy's End children. The parade started at different places and the route of the march differed accordingly.

Brenda Broome

I went to Commercial Street Congregational Church Sunday school. I loved it, we played games and sang songs. At the end, we were given a stamp with a Bible verse on to stick into our stamp book. If you collected enough stamps over the year, you were given a Sunday school prize. It was always a book of some sort.

Sue Hoggarth

St Matthew's Church.

The Church of the Holy Sepulchre.

The Church of the Holy Sepulchre's interior.

1950s–1960s

I went to Sunday school at the Holy Sepulchre Church in town and then St Augustine's Church in Kings Heath. Each week we were give a stamp with a Bible scene for our books. Later I went to confirmation classes. I have always enjoyed hymn singing.

Gill Felton

1960s

I went to Brownies at St Augustine's Church in Kings Heath when I was a child. I really enjoyed it and I had my first trip away from home with the Brownies – we went to Castle Ashby.

Carol Grammer

When we lived in Herbert Street, my sister attended a church and she took me to Sunday school. I had to learn a verse of a hymn and if I did I would get a small bar of chocolate. I remembered the whole thing and got my chocolate plus a pat on the head from the minister.

Sue Hardwick

All Saints Church interior.

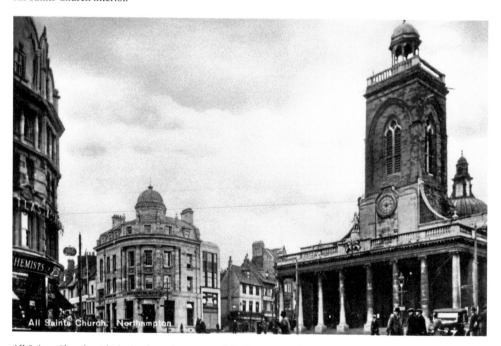

All Saints Church with the bank on the corner of the Drapery and Mercers Row.

1990s

I went to Sunday school at St Alban's in Broadmead Avenue and we went to the church service. I liked it because I was used to it but it was more formal than the other churches I knew. It was

quite a cold building but there were some nice people there. I went to Broadmead Baptist Church sometimes because I attended nursery there and we were sometimes invited to services. I liked that church, it was very friendly and comfortable. I went to Headlands United Reformed Church for church parade services with Brownies and Guides. It's surprising how many churches there were within walking distance of my home.

Emily Jones

I went to Sunday school when I was young but I have no real memories of it. Sundays changed for me when I was given freedom to choose if I wanted to play football on a Sunday, so that replaced Sunday school. Grandma complains that 'Sundays aren't sacred anymore'. She's not religious, but is outraged that shops are open.

Lewis Godbolt

I went to Sunday school at St Alban's Church. We went into the church service when they had communion and we went to the altar to be blessed. The people at church were all nice to us, but I preferred Broadmead Baptist Church because it was more lively. We went to services there sometimes. I enjoyed Brownies and Guides at Headlands United Reformed Church but I disliked church parade.

Laura Jones

When I was younger we went to Baptist Church, but now I go to Park Avenue Methodist Church and I participate in various church activities. I went to Cubs and Beavers at Saint Matthews Church and holiday clubs at Abington Avenue United Reformed Church, I liked it there. Now I'm a leader in the holiday club at my church.

Simon Hoggarth

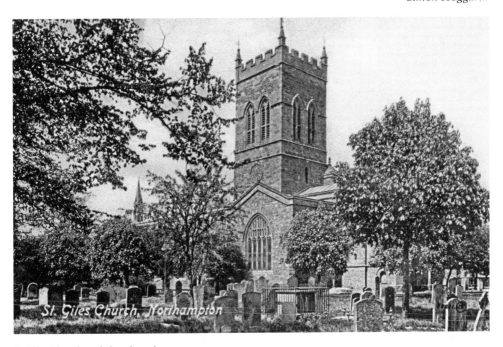

St Giles Church and churchyard.

Work

Dad lived in Whitworth Road. When he left school he worked as an errand boy at Stow's butchers on the corner of Billington Street. He delivered orders, assisted in the slaughter house at the side of the shop and was gradually taught the trade. He worked there for about twelve years.

Before her marriage Mum worked at the Brook dress factory in Clarke Road. It was a big factory with a large workforce. Mum worked in the undergarment department making petticoats. It was a good skill to have because she could make anything, she made all our clothes.

In 1927, Dad was offered a job at Hunts fishmonger shop in Wellingborough Road opposite Victoria Road. The pay was a bit better so he became a fishmonger and he worked there until he died in 1965.

Joan Clarke

At fifteen I left the cosy environment of school, and started work. My first day as a hopeful apprentice electrician was spent in the loft of a church poking wires through the ceiling for the new lighting. It was hot day and the loft was like a furnace but I did not dare come down until the job was done. It became obvious that I was just employed as cheap labour for £3.00 a week.

I got a job at Savages on Kettering Road. They owned two shops just past Grove Road, which were split across three shops with a baker's shop in the middle. One sold paints, easels and art materials as well as paintings and the other sold books. I enjoyed working at Savages, but after a few months, I had the opportunity to move on to electronics, which was my dream job. At that time the company was known as Yale Automation based in Kettering Road between St Michaels Road and Grove Road. The company has moved to Desborough and has a different name but I am still there!

Michael Cunnew

Mum did work for the Giesen and Wolfe greetings card company. She either had to stick bits onto cards or add inserts. The work enabled Mum to get our television. She used her earnings for extras.

Originally Dad was a signalman on the railway, but he left the railway to become a telephonist at St Edmund's Hospital because he had been trained as a telephonist during his military service. Later he worked in the front hall at St Crispins Hospital and I sometimes sat with him when he worked in the evening. His old-fashioned switchboard fascinated me but it was soon upgraded. All calls went through the switchboard, so he was kept very busy.

Sue Hoggarth

My father worked as an engineering inspector in the Hinge Shop at the Simplex Factory in Roade and caught the 7.30 United Counties bus from Delapre Gates every Monday to Saturday to work.

Colin Skears

Dad was a master grocer, he started work for the Co-op when he was fourteen and he did a type of apprenticeship. He served in the army and then returned to work at the Co-op in Ambush Street, where he met my mum. In 1947 he rented a shop in St James Park Road next to the Castle pub. I was born in the flat above the shop in 1948 and I lived there throughout my childhood.

I remember sweets and the biscuits being on ration. Dad bought sugar in big sacks and weighed it into blue gusseted bags. Flour was also weighed into bags. Butter came ready packed but some people couldn't afford a whole pack and they wanted to buy four ounces or even two ounces so he cut a pack up for them. A lot of people hadn't got two ha'pennies to rub together and Dad knew who really needed a bit of help.

He worked very hard with deliveries, purchasing and running the shop. He went to a big place in Clarke Road if he needed additional stock and he went to Squires, fruit and vegetable wholesalers in Lower Harding Street. In later years he used the cash-and-carry at Lodge Farm. On Thursdays he bought the fruit and vegetables for the weekend, collected customer order books and delivered orders to customers in Blisworth. Friday was very busy because it was pay day. Dad had a 'strap book' so all the people who had bought things 'on tick' came in to pay what they owed. On Saturday he delivered grocery orders while Mum was busy in the shop.

He boned his own meat and he bought great big bacon shoulder joints and boiled and sliced his own ham. There was a big heavy freezer but we didn't have a fridge, Dad used a cool cupboard. Very few people had fridges then. Half closing day was on Thursday, but Dad didn't close the shop. Almost everywhere was closed on Sunday but he opened the shop for a short time.

Brenda Broome

Frank White working in the Front Hall St Crispin's Hospital, 1966. (© Sue Hoggarth)

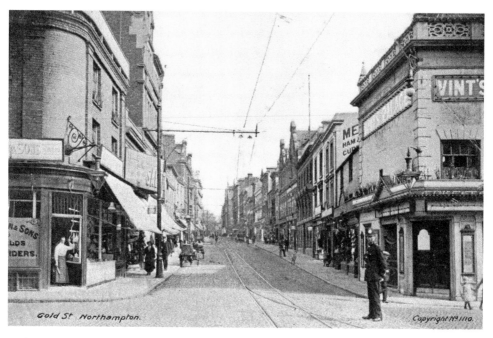

Looking up Gold Street towards the town centre.

1960s

My grandfather worked most of his life as a clicker at C & E Lewis in St James. The shoe industry was all encompassing – if you didn't work in it you had family or friends who did. In my childhood there were still shoe factories around almost every corner and many of my friends' parents worked in the factories. They were integrated with the housing, and they were part of the community.

I often went to builders' merchants to get supplies with Dad. Places like Cleavers in Wellington Street, Bells at the bottom of Gold Street and a place along Southbridge Road. Those places were a slice of Northampton life.

Clive Hardwick

Timken was a massive employer in the town, and Express Lifts had a large workforce too. When I left school, most of the girls went to work at Barclays clearing house but I was lucky to get a job in the planning department at Timken in Duston.

Carol Grammer

1970s

My first job when I left school in 1969 was at Express Lifts. I started as a junior shorthand typist in a typing pool. I worked with some great characters. Messages were sent via 'telex' and the phones and main switchboard, with the pull-out wires, were very 'retro'. I am so pleased we have the Express Lift Tower in recognition of a great company that provided many jobs in Northampton.

Gill Felton

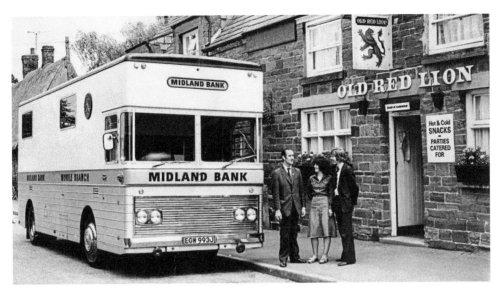

The Midland Bank mobile bank, 1970s. (Used with permission from Gayle Law)

Mum worked at Hillard's Supermarket and Dad worked at Midland Bank. He drove the mobile bank to all the big companies in and around Northampton. Prior to his job with Midland Bank Dad worked as a bus driver. I was very young but I vaguely remember going to meet him at the depot in Derngate, it was noisy with a strong petrol-fume smell.

His first job was on the railway, he started as a 'knock up' boy who had to go to all the railwaymen's houses in the early hours of the morning and knock their doors to wake them up for work.

Gayle Law

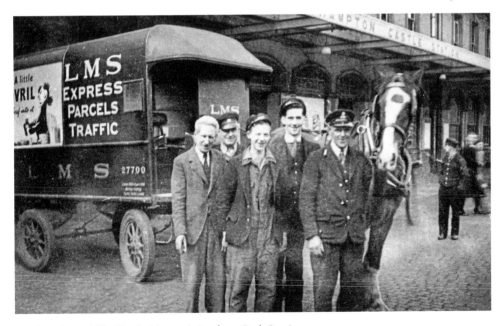

Castle Station, 1930s. (Used with permission from Gayle Law)

Town Centre

On a Saturday morning I went down to the fish market with my mum to buy winkles, mussels and some faggots. Then we went to the market for whatever Mum needed. Dad had an allotment at the top of Boughton Green Road so we were never short of vegetables.

Wendy Simpson

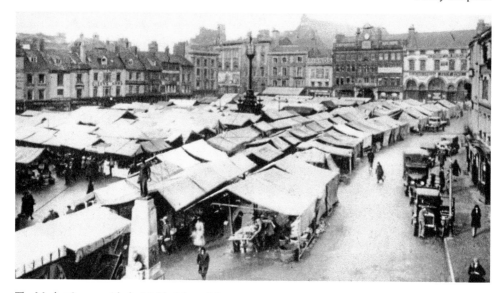

The Market Square with the Mobbs Memorial statue.

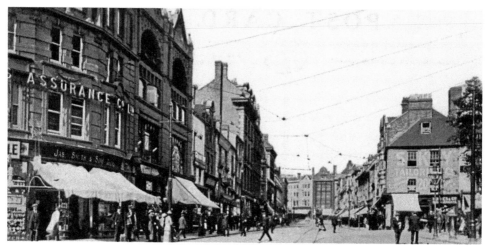

The Drapery from George Row.

I bought records from Woolworths or Boots. Woolworths sold Embassy records, which were cheaper than other labels. They were fragile Bakelite records. I bought boxes of gramophone needles because I had to change the needle and wind the record player after each record to avoid scratches. Dad worked in the Peacock Hotel on the Market Square as a barman. You could buy all sorts of things from the market, the square was full of stalls. I liked the joke shop in the Emporium Arcade

My first job was at Philadelphus Jayes in the Drapery. It was still quite old fashioned when I went there, but during my time there they added a new floor where they sold gifts and perfume.

Yvonne Bodily

1950S

I remember going into the Co-op with Mum after the war when they still had clothing coupons. I used to go to the toy shop in the Emporium arcade to buy Dinky toys and Britain's farm animals. The fish market was always running with water because they had everything on ice and as it melted the water ran away along the gullies.

Roger Broome

I was fascinated by the strange payment system at the Co-op. They had a lift, and a uniformed attendant operated it. Occasionally I was taken for a high tea at the Ridings cafe. It was just a pot of tea and cakes on a proper stand. It was silver service with waitresses in black dresses with white aprons. The cakes were the same price and you paid according to how many cakes you took. We visited Father Christmas at the Co-op. There was a beautiful rocking horse in the children's shoe department.

Gold Street was a busy shopping street with nice shops including Woolworths, Marks and Spencer's and Boots. The fish market sold all types of fish and meat. We bought pork scratchings from there. The market was huge and you could buy anything you wanted. Golby's stall was

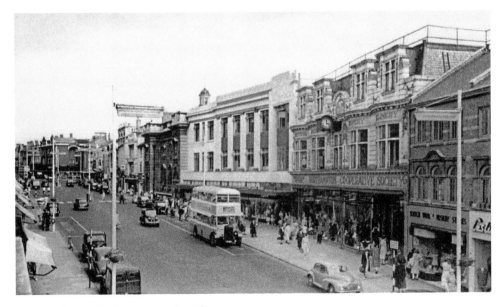

Abington Street with the Co-op on the right.

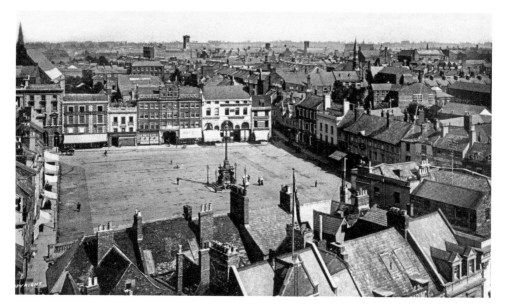

Looking across the Market Square from All Saints with the Emporium Arcade on the far side of the square.

near the fountain and they displayed their plants around the base. I have happy memories of the Emporium Arcade – I loved the joke shop. Ables' music shop was on the corner, that's where my Portadyne record player came from.

Brenda Broome

Gold Street was Mum's main shopping street. The Drapery was always very busy with lots of bus stops and Bridge Street was much busier then. Macfisheries in the Drapery sold all sorts of fish and shellfish, which were scooped into a bag with a beer tankard. Mum took me to the fish market in my pushchair to collect the free orange juice for under-fives. The thing I loved most was called

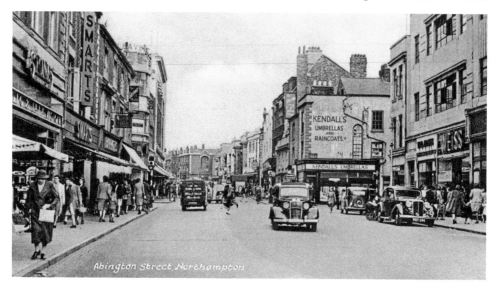

Abington Street.

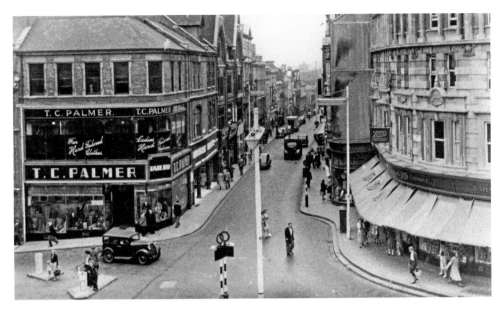

Looking down Gold Street with Bridge Street on the left and the Drapery to the right.

Virol, it was lovely, just like a spoonful of toffee. All the market stallholders shouted to attract attention to their stalls. The market was packed; you could buy anything, tea sets, rugs or even pets. I bought a goldfish and carried it home in a bag of water.

Sometimes we went to the Milk Bar in Abington Street. They had high stools and there was a picture on the wall of the Beverley Sisters having a drink at the milk bar. Like most children, I was fascinated by the Co-op payment system. It was a treat to visit Coldhams at the top of Abington Street because they had a slide down to the basement. I got a Sooty xylophone from there once. Every December they had Father Christmas at Coldhams, Pooles, the Co-op and Adnitts.

Sue Hoggarth

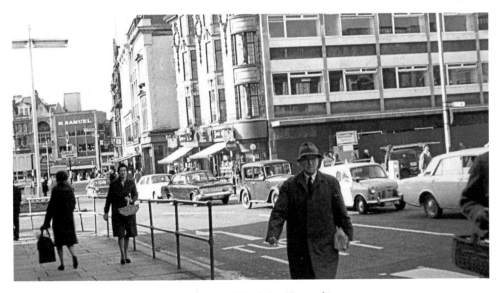

Abington Street looking towards Mercers Row 1968. (© Sue Hoggarth)

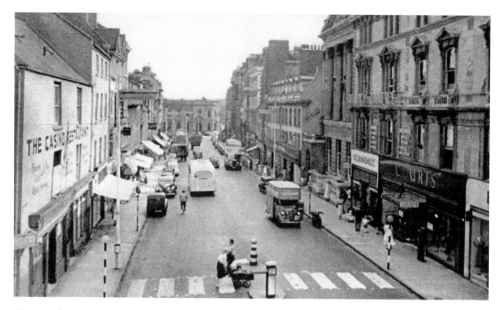

The top of the Drapery looking towards George Row.

1960s

I remember the town as bright, lively and bustling with people. I was always taken around the Market Square on Christmas Eve which was a treat, all the stalls had Tilley lamps. I have a lot of good memories of Christmas. We went to the toy fair at the town hall involving local toys shop and there were usually a few train sets on display. Pools on Abington Square had open evenings and I saw some lovely train sets in there too

I was fascinated by the Co-op Arcade – the lift was a tremendous experience and it was a maze of departments and you could enter the shop in one place and come out somewhere else.

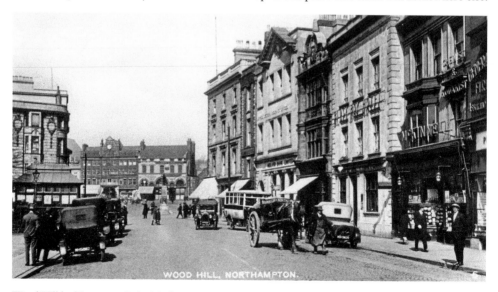

Wood Hill looking towards the Market Square.

When you paid at the counter there was no money held in the shop; the assistant sent the money to the cash office using a vacuum process and your change was returned in a similar manner. Downstairs they had a record department, with booths to listen to music and they sold musical instruments. Boots, on the corner of Gold Street, also had a record department downstairs. I knew where all the record departments were. I spent a lot of money on Memory Lane records in the Emporium Arcade because they sold used records, so you could buy things that you couldn't afford to buy new.

Clive Hardwick

A market stall started selling cheap ex-jukebox records. I went to the stall most Saturdays to add to my collection. The stallholder moved into a shop in the Emporium arcade, which became Memory Lane Records. When the arcade closed, the shop moved to Derngate. The Golden Disk, in Marefair, also sold similar records.

Sue Hoggarth

Mum bought fabric from the market to make clothes and we bought whatever we needed from the fruit and vegetable stalls. The fish market was massive with lots of stalls; we bought our fish there.

My grandmother lived in Newland, near the Bull and Butcher pub, and the Emporium Arcade led from Newland to the market square. There were lovely wrought-iron workings painted in cream in the Arcade but it was in decline. There was an echo and my brother and I used to run up and down shouting so that we could hear the echo. Peacock Way had a lot of nice shops, including a fabric shop called Henley's and a good hairstylist, which Mum used to go to.

I loved the Co-op Arcade. They gave blue Co-op stamps with each purchase, a similar concept to green shield stamps. We bought milk tokens at the Co-op to pay the milkman. Their strange system for handling money was similar to the Lamson Tubes system used for documents when I worked at Timken. I thought it was brilliant.

Carol Grammer

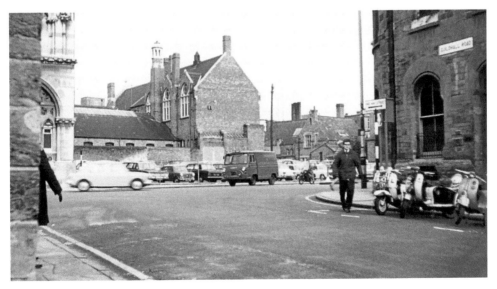

St Giles Square from Guildhall Road as seen in 1968. The Guildhall extension was built some years later. (© Sue Hoggarth)

1970s

In the early 1970s, we did our main food shop at 'Fine Fare' at the top of Abington Street until we began to shop at Hillards on Weedon Road. On Saturday mornings, I went to town with Dad. We bought prawns at the fish market and we went to the Co-op Arcade to buy milk checks to pay the milkman. We queued to buy a pork pie from Saxbys in Peacock Way and I looked in the window of 'Elizabeth the Chef' at the wonderful cakes. We went to Oliver Adams on Wood Hill and I chose a cake; I loved synthetic cream donuts. Terry Wogan came to Northampton in the late 1970s to open Huckleberries on the market square. It was our first takeaway hamburger restaurant.

Gayle Law

1980s

Mum and I caught the bus into town every Saturday to do the shopping. I hated the fish market because I couldn't stand the sight or smell of fish. They built Peacock Place in 1980s and it seemed to take ages. The market was much more lively then. We bought fruit and vegetables there and we often went to the haberdashery stall. I loved choosing the buttons and trimmings for the clothes Mum made for me. She bought the fabric from the market too.

Tracy Webb

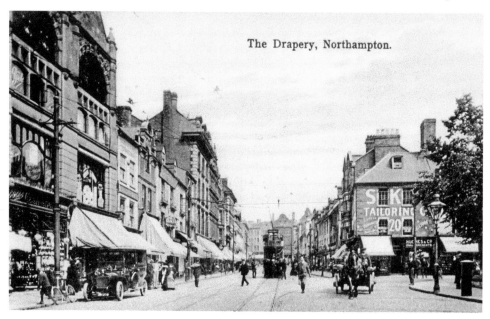

The Drapery, Northampton.

The Drapery and Mercers Row.

1990s

We went to a shoe shop at the top of Wellington Street for football boots and trainers. I bought Mr Blobby pink lemonade in tiny cans and pick and mix from Woolworths and it was a good place to buy CDs too. We often walked through the Co-op Arcade to St Giles Street because

Looking towards All Saints Church from Bridge Street with George Hotel on right not listed.

Coleman's the stationers was one of my favourite shops. The street feels different from the rest of the town and the church and churchyard are beautiful. I spent my pocket money on music books from the shop in St Giles Terrace and I loved the arts and craft shop on Abington Square, we went to classes there during holidays.

The market seemed huge and I loved the jewellery and bag stalls. It took me years to work out that the man selling newspapers outside the Grosvenor Centre was shouting 'Chronicle'. We met our friends at the Disney Store because it was the nearest interesting place to the bus station and HMV was opposite so you could look in there if they were late.

Emily Jones

When I was growing up, the town centre seemed an exciting place with plenty of interesting shops. Now when I walk down Abington Street, there is little of interest – I rarely go shopping in town. As a child I enjoyed going to toy shops, including Watts on Abington Street, Toymaster in the Grosvenor Centre and I loved the Disney Store. I remember queuing up with my dad to get a Buzz Lightyear toy and I was very lucky to get one before they ran out. The market used to be much bigger, with all sorts of different stalls. One of my favourites sold second-hand toys, collectables and action figures, and another sold die-cast Thomas the Tank Engine models. I liked to go to the fish market because there were two very nice books stalls in there.

Simon Hoggarth

When I went to town with Dad he always went to Debenhams menswear department and sometimes we had breakfast in the restaurant. We went to the food hall in Marks and Spencer, and we often arranged to bring the car to the side entrance to collect our bags when we had finished shopping. Grandma usually took me to clothes shops and I liked Miss Selfridge but it

has gone now. I don't enjoy town as much as I used to but I still like to shop in St Giles Street because it has some good shops and it feels nicer than the town centre.

Laura Jones

1990S–2000S

I used to love going to the market. I remember buying two of my first films on VHS from the video stall. When the market was thriving there was a confusion of smells and sounds, with many stall holders shouting out to attract customers to their stalls and the *Chronicle and Echo* seller outside the Grosvenor Centre shouting 'Chron-i-cle!' When they 'modernised' the Market Square, they got rid of a lot of stalls and suddenly the market lost its magic. It felt empty and unappealing and it made the Market Square much less attractive. If I had to summarise my memories, I'd say that I remember people more than the individual shops. There are some real characters in Northampton.

Sam Jones

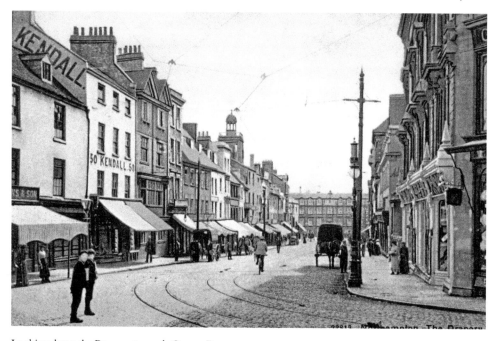

Looking down the Drapery towards George Row.

Sport and Leisure

1950S

We occasionally went to the Friendlies Club near Newland on a Saturday. Dad taught me to dance from a very early age; the waltz, barn dance, the Valletta and more.

Gill Felton

We went almost everywhere on our bikes, even down the Banks or St Leonards Road for a 'piece and six' from the chippy (with batter bits, salt and vinegar, of course!). As I got older, mileages grew and I rode with my brother to other towns and with school friends we ventured out on Sunday coach outings. Life was one great adventure.

Colin Skears

Franklins Gardens when it was pleasure gardens.

1960S

I loved the Cobblers and I hung out of our top room window to watch the matches. I could see half the pitch and one goal so the sound of the crowd told me what was happening when I couldn't see the action. My first game was the season before they went up to the First Division in 1964, I watched them beat Newcastle one-nil. In the first division season, I went to a couple of games but I watched most games from the window. When I was older I went regularly.

Clive Hardwick

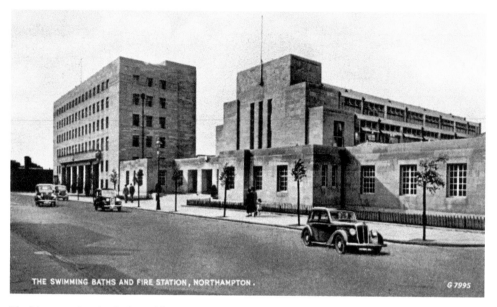

The Mounts swimming baths and fire station.

We went to the Mounts baths early every Sunday morning. I remember the chlorine smell, the heat, the changing rooms, the lockers, and the disinfectant pool you walked through to keep verrucas at bay. I also remember being too scared to go on the diving boards! Midsummer Meadow was much more fun because it was outdoors. The water was warmish and brown. Once I scraped my foot on the bottom and got it severely infected.

Clive Hardwick

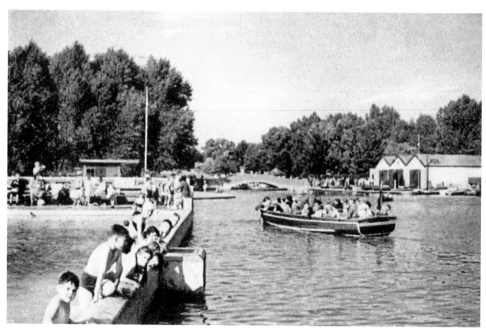

Wicksteed Park.

I belonged to the masque theatre group and I participated in all sorts of events. On Tudor day at Abington Park, a group of us performed a twelve-minute version of *Hamlet* called 'Hamlet in a Hurry'. We performed it about ten times throughout the day.

Simon Hoggarth

The old gateway, Abington Park (near Anington Park Crescent).

Events

1950s

Our headmaster came into the classroom and told us that King George had died and his daughter become queen. We said the Lord 's Prayer and we had a minute silence, which seemed to last for ever. Afterwards he said that there would be a coronation and it would be very exciting. After King George's funeral, everyone started planning events for the coronation. It was decided that all the children would come to school in fancy dress and we would each be given a mug to commemorate the coronation in a little ceremony in Thornton's Park. On the day of the presentation, each class was marched down to Thornton's Park in great excitement and we all waited eagerly for our name to be called to receive a mug.

On coronation day we went to a neighbour's house to watch it on television; we were spellbound and it stays in my mind to this day. When the coronation was over we went to a party held in a garage on Kingsthorpe Grove, near the Romany pub. There were children's games, barrels of beer and large amounts of food; we had never seen anything like it before. The women had been saving food for months to make this wonderful spread. The children were given a coin with the queen's head on it and we had bags of sweets. There was a fancy dress

Flowers outside Althorp House the day after Princess Diana's funeral.

The carnival 1992 in St George's Avenue with the former girls' grammar school in the background. (© Sue Hoggarth)

competition; I was dressed as one of the queen's ladies but I didn't win. There was no music but there was great merriment, with everyone singing and dancing. It finished at 10.00 p.m. with everyone doing the Hokey Cokey.

Wendy Simpson

1990s

I remember Princess Diana's funeral. I stood in Bants Lane to see the hearse go past, everyone lined the streets and threw flowers on to the hearse. The next day I took a rose to place outside Althorpe House, they allowed the children beyond the barrier to take flowers.

Simon Hoggarth

The Carnival Parade

1950s

The carnival was previously called the 'cycle parade'. I remember the excitement of seeing all the spectacular and strange cycles in front of the carnival procession. We watched it from the upstairs windows my grandmother's shop in Campbell Street.

Gill Felton

1960s

We always saw the carnival in Wellingborough Road towards the end of the route so a bit of the sparkle was gone. We threw pennies and halfpennies and children ran to pick up dropped coins to throw them again. It included bands, the mayor, the carnival queen, people on decorated lorries, people in costume walking and even people on ancient bikes.

Clive Hardwick

1970s

I loved the Mettoy float at the Northampton Carnival in 1970s because they always threw balls out to the crowd.

Gayle Law

The Northampton Show

1960s

We went to Northampton Show in Abington Park and to the fireworks in the evening. It was a good day out with show jumping, bands, various events and marquees with flowers, handicrafts and small animals. There was always a fair too.

Clive Hardwick

Cattle at the Northampton Show in Abington Park, 1991. (© Sue Hoggarth)

Heavy horses at the Northampton Show, Abington Park, 1990s. (© Sue Hoggarth)

1990s

I loved the town show, I liked the motorbike display teams and the stunt teams. One year I played against the country chess champion and (with a lot of help) I won.

Simon Hoggarth

The marquees were very hot. I liked the farm animals in the NFU tent, I enjoyed watching the show jumping and heavy horses in the arena and I was fascinated by the reptile display. There were handicraft and horticultural displays and lots of activities. The fireworks were brilliant.

Laura Jones

Timken Show

1960s

Timken Show was as big as Northampton Show. Dad was shift foreman in the automotive shop at Timken and we always went to the show. We went to see the bands and Royal Artillery gun displays on the Friday evening and we went back for a full day on Saturday. They had show jumping and lots of things to see. There were displays of budgerigars, canaries and small animals, and horticultural and baking competitions. It was a fantastic day out.

Carol Grammer

The horticultural tent, Northampton Show, Abington Park, 1971. (© Sue Hoggarth)

The Balloon Festival

1990s

The Balloon Festival on the racecourse was brilliant. It had stalls, competitions, a balloon race and arena events. I loved the hot-air balloons; we went in the evening to watch them taking off. There were character balloons including Rupert Bear, Bertie Bassett, the Caramel Bunny, Sonic the hedgehog, a pylon, and a roll of film. Usually the balloons took off in the early morning and the evening and it was lovely to see them coming over the house.

Emily Jones

I used to love the balloon festival. I went up in a hot-air balloon when I was young, but it was during the foot and mouth crisis so the balloon had to be tethered and we didn't really go anywhere! Still a good experience.

Lewis Godbolt

Other Events

1960s

We had a lot of fairs usually on the racecourse or Midsummer Meadow and we had circuses with animals too. I can vaguely remember seeing the circus come through town because they still came on trains until the early 1960s. They had their winter quarters at Duston.

Clive Hardwick

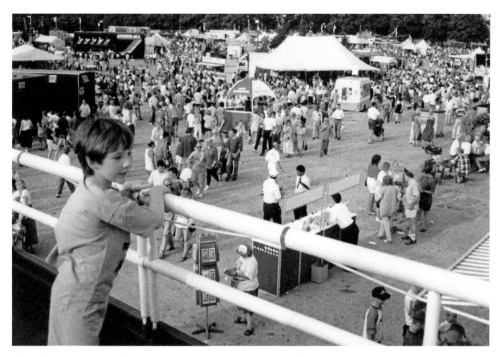

The Balloon Festival on the racecourse in 1995. (© Sue Hoggarth)

Sonic the Hedgehog at the Balloon Festival
on the racecourse. (© Sue Hoggarth)

Entertainment

I spent my Saturday afternoons at the Coliseum cinema on the corner of Balfour Road. It cost sixpence to go in and I had money for an ice cream.

Wendy Simpson

Mum was an usherette at the Gaumont and I went to the children's films on Saturday mornings.

Yvonne Bodily

I was taken to a pantomime starring Cyril Fletcher at the New Theatre in Abington Street. My main memory is having to sing 'The Happy Wonderer' and the words came down on a screen. I went to several pantomimes at the Royal Theatre. When I was very young we went to see *Robinson Crusoe* and sat very near the front. As soon as the orchestra began playing below the stage, I was spellbound by the instruments. I wasn't interested in the pantomime but the orchestra was magical.

Sue Hoggarth

I went to Gayeway in Stanhope Road. They taught us to jive, we danced to all the popular music.

Yvonne Bodily

Skiffle groups became popular and Bill Haley introduced us to rock and roll. I learnt to jive at Gayeway in Queens Park Club. I listened to the hit parade on the wireless and I read every page of the Musical Express. I saved up to buy my first pair of jeans and a pair of psychedelic socks. I was becoming a 'Teddy Girl' and my parents were horrified! We were taught ballroom dancing at the Gaumont ballroom on the Market Square and we jived until we dropped.

Wendy Simpson

On a Saturday night, we all went to the Gaumont in the Market Square or to the Savoy on Abington Square and sat in two long lines across the middle of the cinema. We all walked back together, but the lads were older than us so they ran down the hill to The Welcome to get a drink before closing time and we sauntered along behind.

Brenda Broome

I loved the ABC Saturday morning cinema. It cost sixpence. I had two shillings and sixpence pocket money; one shilling for bus fare, sixpence for the cinema ticket and sixpence to spend on sweets with sixpence left, very good value!

Gill Felton

The pantomime was an annual treat. Going to the panto at the Royal Theatre made us feel grown up because we could stay up late and we could have a tub of ice cream. Everything was magical, the bright lights, the curtain going up, Maurice Merry and his Merry Men in the orchestra pit, fantastic sets by Osborne Robinson, brilliant costumes, songs and jokes. Great times.

Clive Hardwick

I went to various functions at the Drill Hall, which was an austere place, obviously designed for military purposes. I felt rather intimidated by it. Wrestling matches were held there. We went annually to see 'The Amateurs' perform their musical at the ABC and we also went to 'The Gang Show'.

Clive Hardwick

The Temp in Newland was once a lovely cinema but it was on its last legs. I went there when I was sixteen to see X-rated horror films; no other cinema would let me in because I was too young but as long as you paid the Temp let you in. On one occasion I went to sit down, but there was no seat so I moved along and saw that springs were sticking out of the seat. You were lucky if the film didn't break down half a dozen times, plunging the whole place into darkness and sometimes rats ran under the seats. Happy days!

Michael Cunnew

1970s

At the Salon in the 1970s, Wednesday was disco and Saturday was disco and ballroom dancing. The dance floor was large and ideal for ballroom dancing and it provided a wonderful meeting place.

Gill Felton

1980s

I loved Cinderella's, which was formerly the Salon. I went to go on 'teen night' for ages thirteen to seventeen on Tuesday evenings. It was my first experience of going out and I was mesmerised by the lights and the disco smoke. We were desperate to get through to Rockerfella's on the other side, but the bouncers in the middle managed the over-twenty-one area. When I was old enough I wondered what all the fuss was about. I remember lots of white stilettos and fluorescent lighting, which revealed your underwear through your clothes and made your teeth look luminous.

I queued round the corner each week, waiting to watch a film at the ABC cinema. It was very smoky and a public announcement asked all smokers to sit to one side.

Gayle Law

While at university, I participated in Film Northants and had a film shown at Cineworld. I submitted a short documentary about a theatre group and my film was shown with the other films in the final. I didn't win but the special screening at Cineworld was very exciting with a red carpet, sparkling wine and glamour like a film premiere. It was amazing to see my film on the big screen.

I went to the Canon cinema on Abington Square to see *Beauty and the Beast* when I was four and I have loved films ever since.

Simon Hoggarth

The Virgin Cinema in Sixfields was better than Sol Central and, when I was young, I was very impressed by the drinks holders. I went to the Forum cinema at Weston Favell often and I saw some good films there. The ABC cinema was a brilliant example of how a cinema should be set up, but at least the building is still standing.

Sam Jones

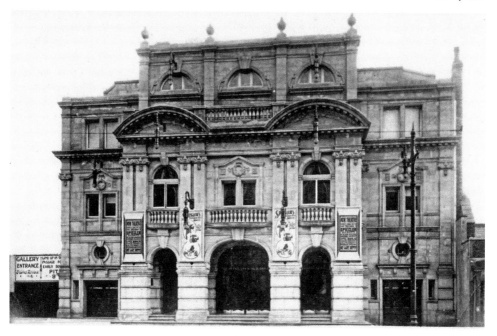

The New Theatre, Abington Street.

Transport

Railway

1930S

Dad began his working life on the railways. He used to ride to Lamport signal box during the war and climb the signal box to watch all the planes going off each morning. He went back at night and counted them back in, realising that some had not returned.

He once met Noël Coward, who had missed the last train back to London after performing in Northampton. It was cold, so he asked my Dad if there was anywhere he could keep warm for the night. Dad let him into the staff room at Castle Station and they played cards all night, waiting for the morning train.

Gayle Law

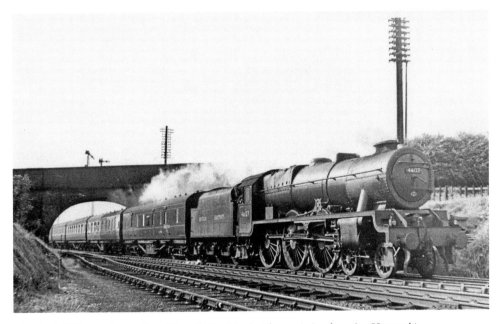

The No. 46127 near Gayton Signal Box, 1940s. (Used with permission from Sue Hoggarth)

1940S

We played on St John's Station. It wasn't used for trains any more but we could get up the steps onto the platform and I used to ride my scooter along there. Mum took me to London on the train from Castle Station occasionally; we had steam trains, rail travel was very exciting. I didn't use Bridge Street Station until the early 1960s but I don't remember where I went.

Yvonne Bodily

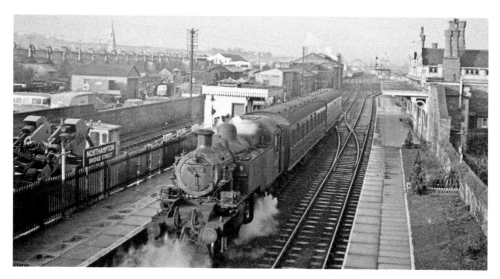

The No. 41224 at Northampton Bridge Street on 17 February 1962. (© Christine Jones)

1950s–1960s

Trainspotting was an important part of my early years. It was a common joke to tell your friend that there was a 'Hall' on shed and when they asked which one, the reply was either 'bugger all' or 'sod all', because as far as I know it never happened, despite there being several hundreds of them in existence. The other favourite was to say there was a named Black Five on shed and watch people chase down there to find it was not there. This was funny until one actually turned up!

We often got up to mischief of some sort or other. The first hobby was to put pennies on the line and then try to find them after an express had run over them. Also in Roade Cutting, under the black bridge, there was an access hatch between the two fast lines that you could climb down and watch the trains thunder past your head. At Roade station you could see how long it would be before the stationmaster chased you off the platforms, and similarly how long before you were chased out of Northampton Shed on weekdays. As a dare we would walk along narrow bridge parapets, Rothersthorpe Road Bridge being a favourite.

Colin Skears

I remember once going on the train to London and it was diesel on the way but steam on the way back, it was a Black Five and it's the only time I travelled on a scheduled steam train on the mainline. I remember being amazed because the diesel had steam coming out of it and it was only years later that I realised the steam came from the boiler for the carriage heating.

Clive Hardwick.

Bus

1950s–1960s

Buses were very frequent and our local buses ran until past 11 p.m. There were a number of different fare stages so even by walking a fairly short distance you could save a ha'penny on your

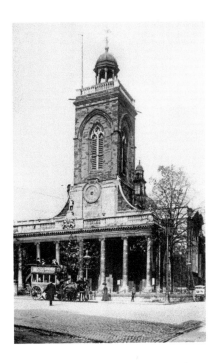

All Saints Church with a horse-drawn tram outside.

fare. The conductor had a leather pouch of money across one shoulder and the ticket machine across the other. The tickets were all pastel colours with a unique number and the fare amount pre-printed on the ticket. We all collected bus tickets as kids. We liked to sit upstairs at the front of the bus.

Clive Hardwick

1960s

We had a red bus when we got married. I worked at the town hall so the reception was held there. Few people had cars so we hired a bus to take everyone from the church to the reception. Everyone climbed onto the bus, and Dad asked if he could ring the bell. I think ringing the bell was the highlight of his day!

Brenda Broome

The traffic control centre above
Greyfriars Bus Station. Heritage
Weekend 1999 . (© Sue Hoggarth)

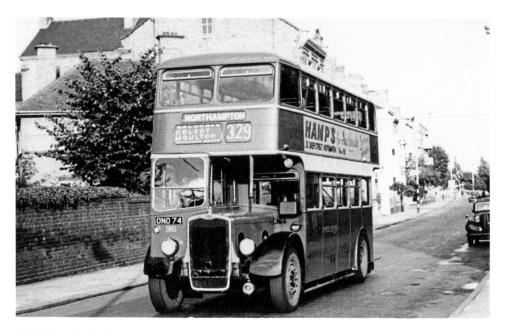

United Counties bus in Derngate.

I went to live in Boothville when I got married. It was further out of town than anywhere else I had lived and it was served by United Counties buses rather than the red Northampton Transport buses. The green buses took us into the bus station in Derngate.

Yvonne Bodily

1970S–1980S

We usually used buses because we didn't have a car. I didn't like the escalators at the Greyfriars bus station, they were really fast and I thought I was going to fall off. The bus station was dark and grubby but it didn't feel unsafe.

Tracy Webb

1990S

I saw the upstairs part of Greyfriars bus station on Heritage Day. In the control room, I saw how the cameras moved around and how the bus station was managed.

Simon Hoggarth

If you entered Greyfriars bus station on a bus, daylight would cease suddenly, which was an unnerving experience and I can understand why it was referred to occasionally as 'the mouth of hell'. No matter how many people were in the bus station, there would always be more pigeons! I think they lived up in the rafters, above the lights. There were spikes to deter them but Northampton pigeons are very determined, and they will not budge even if you scare them!

Sam Jones

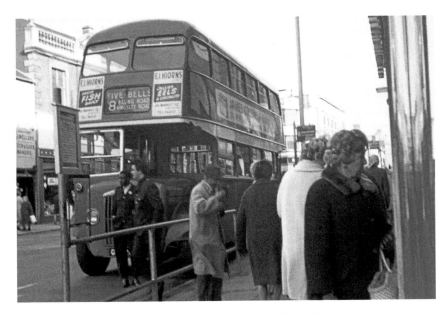

A Northampton Transport bus in Abington Street. (© Sue Hoggarth)

Car

1980s

My dad fixed a lot of cars but we didn't own a car. He borrowed his friend's old three wheeler to take us to the seaside. It was a two seater so Mum and Dad were in the front with me and my friend behind on a shelf. There were no seatbelts but we drove to Hunstanton two or three times a year in it. When we got there my bottom was numb and I felt stiff due to the cramped position.

Tracy Webb

The M1 in 1970, taken from the bridge at Whilton Locks. (© Sue Hoggarth)

War Years

Much war-related traffic passed through Wootton, including a trio of elephants. They were fed and watered at Hanfords bakehouse on High Street on their way to Salcey Forest to do their bit for the war effort. One hopes they survived the war.

Jim Frampton

My cousin was in the catering corps during the war. He was stationed in a big house in Newland, which was used as a catering centre for some of the soldiers who came to Northampton. The military commandeered all the big houses.

We had several evacuees, first a lady with two daughters came and later on we had my three cousins from London. I can't think how we managed, we had to feed them but we coped somehow.

Joan Clarke

We were instructed to call at different buildings to collect our uniforms and equipment, and then shown to our wooden huts known as the sleeping quarters. These looked like a hospital ward, with twenty beds lined along each side of the wall. Others of our intake were allocated to Nissan huts, which were temporary buildings with curved roofs of corrugated iron that were icy cold in winter.

Talavera camp covered approximately half of the racecourse area in a fenced enclosure

Gladys Shaw, from her book *The Smell on the Landing*

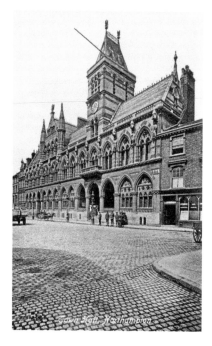

The Guildhall 1914 or 1915 with soldiers.

Changes

1960s

The market has changed, it is a shadow of its former self but at least we still have a market. If you look up at the architecture the buildings around the market are lovely.

Carol Grammer

Berrywood Road in 1967, just past the council houses. It has now been built on. (© Sue Hoggarth)

1960s–1970s

When Dad's shop in St James Park Road was put under a compulsory purchase order it was the worst time of my life. I was working in the town clerk's office so I knew in advance that those houses were due for demolition, but I couldn't tell anyone because it was confidential. It was our home and Dad's livelihood and our lives were tied up in those streets; it was devastating.

Brenda Broome

I didn't grieve for the Emporium Arcade at the time, but I wish it had been saved. In the 1970s, when the redevelopment was happening, I was all for updating the town, but looking back

A model by Clive Hardwick – Frames Tours adjoining and to the left of the Grand Hotel. It was on the west corner of Kingswell Street and was completely surrounded on its two inner sides by the hotel. Also in the photo is a model of Phillips Shop, which stood in Abington Street. (© Clive Hardwick)

I regret the loss of the arcade. I realise now that we have lost the variety that we once had in the town. When I was growing up every shop and every shop front was different, but now there is uniformity and every town is much the same so we have lost our individuality. We had a lot of locally based building companies in Northampton and they built the town. Now we have big national companies who have no understanding or feeling for the area, so they build the same thing everywhere.

When I saw the Barclaycard building in Marefair being demolished it was a shock. When it was built it seemed to be a futuristic design and it was strange to realise that I had lived through the life of a building.

Clive Hardwick

1970S

I had to leave Silver Street Nursery School in 1971 when Silver Street was demolished to make way for the Saxon Inn. I started at St Mary's School on the Mounts in 1972 and while there I witnessed Northampton House being built. During this era, many streets around the town centre were demolished, work began on the Grosvenor Centre and Weston Favell Centre was built on the eastern edge of Northampton at about the same time. Construction of Greyfriars bus station began in 1973 and it opened in 1976. I have fond memories of the old Derngate bus station, which housed the green United Counties buses that covered county routes.

St Mary's School closed in 1975, along with Notre Dame School in Abington Street. In September 1975 I went to Clare Street School. Clare Street was a boys' school but was later mixed. I was grateful that the building found a new use when the school closed. I feel sad

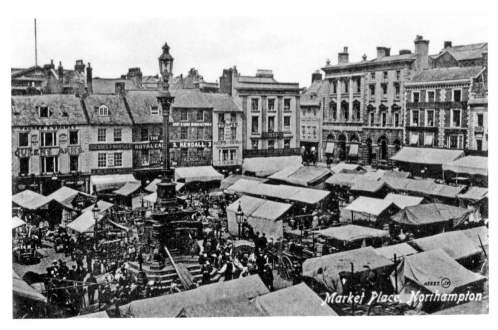

The Market.

when I look back at the demolition of buildings like Silver Street nursery and the Notre Dame convent because the character of the town has been lost. The way the nuns' graves were treated saddens me.

Dominic Bodily

New Town

We discovered that we could be sponsored for housing if my husband found a job in Northampton or Milton Keynes. Neither of us liked the idea of Milton Keynes, whereas Northampton sounded ideal – an established town, with good facilities and, a bonus for me, a history!

After several trips to Northampton from Surrey, my husband got a job at Long & Hambly in Little Billing, and we were offered a house by Northampton Development Corporation in Ecton Brook. I saw it for the first time on the day we moved, and I was delighted. A three-bedroom house with a large kitchen-diner, a decent-sized living-room, nice bathroom upstairs, a downstairs cloakroom and a garden! It was ideal for us.

At that stage, only the area nearest to Great Billing Way had been developed, so we were surrounded by fields, which was lovely, especially for walking the dogs. There was a footpath under the road for access to Great Billing, and the nearest bus-stop to Northampton was on the Wellingborough Road.

Even when all the development in the area had been completed, right up to the Wellingborough Road and beyond, it was still a lovely place to live, with the Ecton brook and woodland close by, as well as the River Nene. The neighbours were (mostly!) very nice, and we got on well. I eventually bought the house under the Right-to-Buy scheme.

Pam Clutterbuck

Buildings

Lost Buildings

I'm sad that St Edmund's Hospital has been demolished. It was once the Workhouse and it held a lot of history.

The demolition of the convent in Abington Street upset me deeply. I had various connections with the convent and I nursed the nuns.

Yvonne Bodily

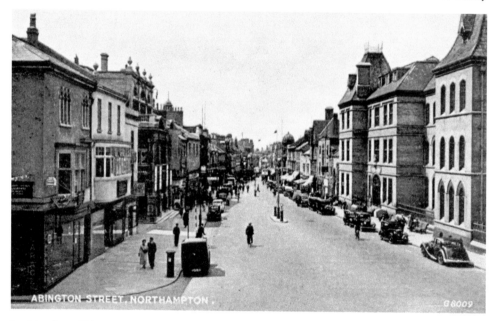

Looking down Abington Street with Notre Dame Convent on the right.

I would love to walk down Newland again. I remember the shops, especially the jellied eels in the window of the fish shop, the clubs and the bingo hall. My grandad used to say, 'When bingo finishes the doors will open and [because of all the smoking] Grandma will walk out smelling like a kipper fillet.' The Emporium Arcade was a favourite of mine, where I spent my pocket money in the joke shop.

Gill Felton

I miss the Emporium Arcade, which ran from the Market Square to Newland. I spent many happy hours in there, attracted by the joke shop and then the record shop. The old *Chronicle and Echo* building was on the corner of the Market Square and further up Newland there was a fish and chip shop nicknamed 'killer Morgan's'.

Michael Cunnew

Berrywood Road looking towards farm buildings prior to their demolition in 1966.

I was sad when we lost the bus station in Derngate. I suppose many people remember it fondly because most people travelled by bus then and an exciting day out usually started from the bus station.

Kings Heath Junior School has been demolished now. It broke my heart when they built on it because I have such happy memories growing up there.

Carol Grammer

I was taken around the *Chronicle and Echo* building on the Market Square and the smell of the hot presses made it feel like a real local paper which was part of our town. We always had the *Chronicle* and the 'green un' sports edition and it was read from cover to cover. The Market Square building is long gone and the building on the Mounts which replaced it has gone too.

Greyfriars bus station was okay but it wasn't just a bus station, there was a lot of unused real estate there. Buildings were demolished but the area was never redeveloped, which was such a waste.

Clive Hardwick

My school was a convent in Abington Street. Although there was a large ornate main doorway the pupils used the small side-door. Inside the building, the many corridors lead to different rooms and it was very easy to get lost and find yourself in the nuns living quarters; which were strictly out of bounds. I was also aware of the secret passages that led from the school under the

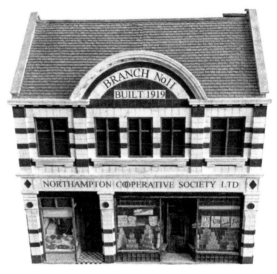

A model by Clive Hardwick – the Co-op was situated on the east side of Mayorhold between Silver Street and Bearward Street. It was built in 1919. (© Clive Hardwick)

main streets of Northampton. I was tempted to explore these passages but I only ventured a few yards before becoming scared and turning back.

The chapel is one of my many memories of the school. It was beautifully decorated and many ornate statues lined the walls. The sunlight shone through the magnificent stained-glass windows, candles burned constantly and there was a warmth which radiated devotion and welcomed anyone entering the chapel.

The gardens that surrounded the building were beautiful. At break times we would stroll around together, exploring every part of the vast grounds. A small graveyard dedicated to the nuns occupied a sunny corner and I would often peer through the wrought iron railings to read the words on the headstones. During my time at the school a very special nun died and the pupils lined the flower covered paths as the coffin was wheeled towards the cemetery. Although it was a sad time, the sun shone radiantly on the coffin as it was lowered into the newly dug grave, making it seem a very peaceful event.

At the back of the cemetery, in grounds of its own, stood a dilapidated old house, with neglected gardens visible from the school. At the time, my friends were convinced that the house was haunted and they spent many hours sneaking along the cobbled path to peep through the broken windows. A few of us remained at the end of the path, watching nervously to see what would happen. As they gazed through the windows any movement inside the house would terrify them and they would rush back to us.

It was a very unhappy experience to see the convent demolished and those beautiful gardens lost under tons of rubble.

Sue Potter

I regret the loss of The New Theatre. Dad told me many stories about when he was a telegram boy and he delivered telegrams to the people appearing at the New Theatre. The theatre declined but it is a pity that the building was not converted for a different use.

I was deeply upset when Cherry Orchard School was demolished and the beautiful grounds were destroyed. It was such a tragic waste of a good school and a very short sighted decision.

Christine Jones

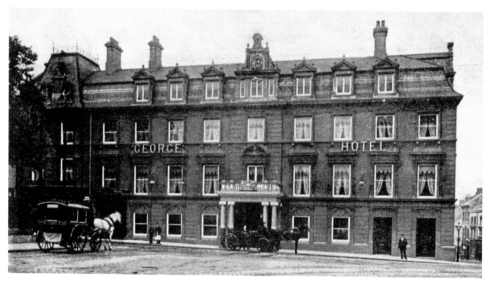

The George Hotel, George Row.

I felt very emotional when they pulled down Cherry Orchard School. It felt as if they were taking away my memories.

Tracy Webb

We lost Charlie the monkey when Gordon Scott's shoe shop close down. I think he was the biggest loss for me, everyone in Northampton loved him.

I hope that the planners will be better at protecting our heritage in the future. I regret some of the recent changes to the Market Square which have not been in keeping with the buildings in the area. In particular, the fountain is an eyesore.

Emily Jones

It seemed pointless to demolish Greyfriars bus station and build a new one that is far too small and in the wrong place. The old bus station worked well, but it had been neglected. It served its purpose, it was close to the shops and it kept people dry.

I was sorry when the *Chronicle and Echo* building was demolished recently. It was a landmark in the town, it wasn't old, but it was eye-catching. It feels as if the paper itself has become more remote.

Simon Hoggarth

I remember going into the fish market with my childminder to buy cockles and winkles. I think it's sad that the building was lost, but being realistic, we can't preserve everything, some things have to change.

I think what's happened to the market is very sad. It's just a shadow of its former self since the 'improvements'. It is part of our heritage and I think the demise of the market is a significant factor in the town losing its sparkle and becoming less attractive to shoppers.

It's a shame that St Edmunds Hospital was allowed to stand empty and derelict for years. As a workhouse it was a place of sadness, suffering and hardship; why would anyone want to preserve it? The site should be redeveloped to provide something useful to the community.

Laura Jones

I'm not overly distraught that the bus station was torn down, but I regret the loss of one particular corridor, it was the exit to 'Rat Island' and the Mounts. I remember running up and down it as a child, it looked a lot longer than it was and I always thought it would look really cool in a film.

Sam Jones

Favourite Buildings

I have always admired the house on the corner of East Park Parade diagonally opposite the White Elephant. I would love to know its history.

Yvonne Bodily

I have a great affection for Bethany Homestead; a sheltered housing scheme jointly built by the Congregationalists and Baptists in 1928. We had a lot to do with Bethany Homestead through the chapel. I loved going there because the residents were always pleased to see us and it seemed to be a bright and cheerful place with lots of open space and lovely surroundings.

We still have a lot of important buildings around the Market Square and All Saints' Church, which need to be cherished. We have conservation areas now so hopefully we understand that these buildings are our heritage and once gone they cannot be brought back. I'm desperate to see something useful done with the old Hawkins factory on the corner of St Michaels Road. There are many examples of factories conversions in the surrounding streets. We have become very good at keeping the frontage and adapting property without losing the essence of the building. Perhaps that will need to happen with the library and the St Giles Street post office in the future. We shouldn't lose these buildings because they are of their time and if lost they will be replaced with more soulless uniformity.

Clive Hardwick

I have to mention Hazelrigg House on Marefare, a Tudor town house dating to the 1500s which, unlike many buildings in the town, survived the great fire of Northampton in 1675. I hope children are taught as much about the history of the town as we were. How can they value our heritage if they don't know about it? We must value and protect our lovely churches and public buildings.

I love Derngate and I am deeply attached to 68, 66 and Becket House on the corner of Derngate and Victoria Promenade; buildings that I knew well when they were part of my school. They held many reminders of their earlier days when they must have been lovely houses. I also like Bedford Mansions, which is a nice example of a 1940s' building.

Christine Jones

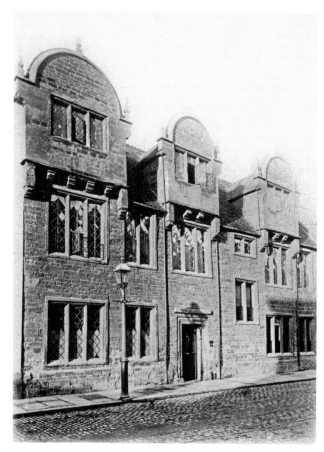

Hazelrigg House (also known as Cromwell House).

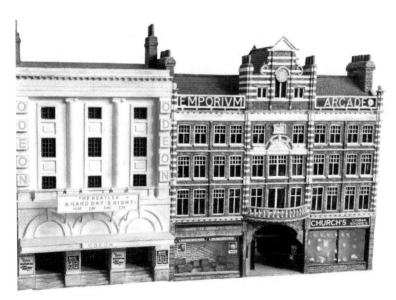

A model by Clive Hardwick – the Odeon Cinema and the Emporium Arcade. Both buildings were on the Market Square but there were several buildings between them. (© Clive Hardwick)

I have very clear memories of standing by the taxi rank looking up at All Saints' Church and realising that it's an amazing building. I hope it will always be there.

Tracy Webb

I love the Royal Theatre, especially the safety curtain; it has style and personality, whereas the Derngate is just functional. The Guildhall looks good on the outside and it is beautiful inside. The whole of St Giles Street looks nice now. There are some lovely buildings in Northampton and we still have so much history around us. We must protect our churches and historic buildings. The library is very nice from the outside; I hope we can keep the building because it adds character to Abington Street.

Emily Jones

Becket House from Victoria Promenade in the 1980s when it was part of Northampton High School for Girls. (Photo used with permission from Northampton High School)

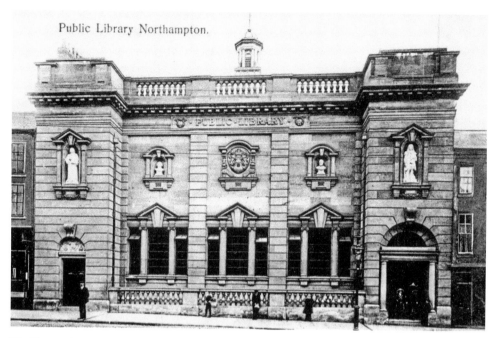

Public Library Northampton.

The library, Abington Street.

We went on a tour around the old courts in George Row and the Guildhall and they showed us the cells where they kept prisoners, and various rooms not usually open to the public. It's vital to preserve the Guildhall because it's the heart of our town, it is beautiful and there is a lot of history attached to it.

Simon Hoggarth

The Express Lift Tower is very iconic. I think is great! I especially like that you can see it on television when the Saints are on.

Lewis Godbolt

The buildings around the Market Square still have character, despite the changes to the market, and the buildings around All Saints' Church are wonderful. The Guildhall extension fits perfectly without detracting from the beautiful Guildhall and St Giles Street is lovely.

The town museum was brilliant, especially the shoes. They had some interesting paintings and the displays about Northampton's history and the fire of Northampton fascinated me. I love the museum in Abington Park. I know everything in it but I still like to go. I've grown to love the building because we were taught about its history.

Abington Street hasn't been sympathetically developed but we must cherish the remaining buildings especially the library. Hopefully future development will give more thought and consideration to the surrounding buildings. The Grosvenor Centre is horrible and Abington Street has lost its personality but hopefully things will improve

Laura Jones

TOWN HALL, NORTHAMPTON.

The Guildhall with All Saints Church in the background.

...GO DOWN INTO SILENCE BUT WE WILL BLESS THE LORD FROM THIS TIME FORTH AND FOR EVERMORE.

The Guildhall during Heritage Weekend 1999. (© Sue Hoggarth)

Acknowledgements

Sincere thanks to all those who contributed time and effort to make this book possible. Without the people who willingly shared their memories and those who gave up their time to transcribe hours of recordings this book would not have happened.

Brenda Broome, Roger Broome, Clive Hardwick, Laura Jones, Colin Skears, Sue Hoggarth, Simon Hoggarth, Sam Jones, Wendy Simpson, Clive Hardwick, Emily Jones, Yvonne Bodily, Joan Clarke, Tracy Webb, Carol Grammer, Michael Cunnew, Dominic Bodily, Gayle Law, Gill Felton, Sue Potter, Pam Clutterbuck, Lewis Godbolt, Mary Grant, Sandy Hall, Lawrie Harold, Jim Frampton, Liz Osborne, George Smith, Robbie Burgess, Clare Jones, Diane Banks, Lawrie Merry, Clare Jones, Lindsay Harrington.

I am very grateful to Sue Hoggarth for sharing so many of her wonderful photos and to Clive Hardwick for allowing me to use photographs of his models in the book.

I am indebted to Paul Hardwick for allowing me to use his late wife Sue's writing and to Georgina Shaw for giving me permission to quote from her late mother Gladys Shaw's book.

The Toy Bus visits the racecourse, 1989.

Abington Park Museum and the Church of St Peter and St Paul.